The Complete Book of

8mm

Super-8, Single-8, Standard-8

Movie Making

The Complete Book of

8mm

Super-8, Single-8, Standard-8

Movie Making

Jerry Yulsman

Coward, McCann & Geoghegan, Inc.

New York

TO
ANITA

ACKNOWLEDGMENTS

Sincere appreciation is expressed to Mort Gerberg and Judith Levine Gerberg, two of today's most professional producers of 8mm films, for allowing me complete access to their extensive film library, and to Joel Holt for use of his magnificent editing facilities and for twenty-eight years of patient tutoring.

CONTENTS

The Complete Book of

8mm

Super-8, Single-8, Standard-8

Movie Making

Introduction

For the amateur movie maker, whether he be a hobbyist or a serious beginner embarking on a career in motion pictures, the 8mm camera is an ideal tool.

The hobbyist will find here most of the information necessary to produce 8mm films in which he can take pride. For the budding professional, the 8mm camera is a practical learning tool, and this text will serve him as a basic primer.

The motion picture has its roots in the live theater. The earliest story-telling films were shot from the point of view of a theater audience. The camera was totally static and recorded the action much as an audience watches a play through the proscenium arch. Motion pictures were called "photo plays," which in fact they were. They differed little from stage plays in terms of their internal structure.

The film medium grew out of its infancy when it was discovered that the camera could be moved. It was as if the "photo play" audience suddenly developed the freedom to get up out of its seat and climb up on the stage. The invisible fourth wall of the theater was no longer necessary. One could now move freely about the *stage* to observe the subject from all angles. Even close up!* Strolling actors no longer had to pause to deliver lines as on the theater stage. In film, there is little fear that the players

*A few exhibitors and film distributors took exception to this, maintaining that their audiences would be confused by the resultant missing torsos.

are going to run out of sight before they run out of lines. When they walk out of shot #1, we can see them again in shot #2, and since the camera can also move with them, there are no limits to the *stage*.

Motion pictures also allow us to see the forest *and* the trees; a long aerial shot of the forest, a closeup of a tree, a minute examination of a leaf. The magic becomes apparent when we realize that the tiny leaf can fill the same screen area as the shot of the entire forest, and be of even greater filmic significance.

Film has become one of our basic means of communication. It entertains, informs, and educates. It has its own language and *grammar*, to which we have all, through exposure, become educated. But just as the ability to comprehend the written word does not make us writers, neither does the ability to understand the language of the cinema make us film makers. For this, it is necessary for one to learn how to *use* the cinematic language and, once that basic requirement has been fulfilled, talent and inspiration can take over.

Since motion picture film was first used as a medium to convey a story, its *grammar*, or internal structure, has grown increasingly sophisticated. We, the audience, have grown apace. If, for example, we could find an individual who had never seen a motion picture and expose him to a modern full-length feature, he probably would have a difficult time following the continuity. The time compression and expansion aspects of cinematic storytelling would confuse him. He would find it difficult to orient himself to flashbacks and flash-aheads. He would be unable to comprehend the meaning of many of the standard and classic filmic transitions. In essence, he would be something of a *film illiterate*.

The grammar of film is still constantly changing. For example, in the past ten years or so, the use of fades and lap dissolves (cross fades) to indicate time or locale changes has almost disappeared, although there are other uses for these techniques (discussed later on) which are still common. Audiences today

generally will accept a time change without the time-honored fade-out-fade-in device. The less sophisticated audiences of D. W. Griffith's time required them.

The best teachers are the films themselves. Much can be learned if one watches a major movie five or six times. One is usually caught up in the plot during the first few viewings, but after that it is easy to observe the techniques used by the cinema photographer, the director, the editor, the lighting director, and the music composer. Since the 8mm film maker usually fills all of these positions, he can learn a great deal which will be applicable to his own productions. Note the camera angles, and how they enhance the action; note the lighting, and the way in which it adds to the mood of interior scenes. Keep track of the cutting in individual sequences to acertain how the film editor created continuity, and make note of how many separate shots were necessary to accomplish this. Try *consciously* to relate the music to the picture so that you too may learn how to point up action, create suspense, and enhance the unconscious emotional quotient of your films through the use of music.

Much of the knowledge you acquire with this method is applicable to all kinds of films, be they vacation travelogues, documentaries, or ambitious full-length dramas. Film language is the same, regardless of film content. The prime purpose is to communicate an idea, a story or a descriptive essay.

Since most films consist of a series of short individual sequences, by experimenting with simple story-telling films you will learn much of what is involved in the production of these sequences. In the process of editing a short film of four or five sequences, you will discover how to shoot for editing, how to make certain you have sufficient *footage* (exposed film) for the *cutaways, the inserts, the closeups,* etc. (described later).

So, using this book as a guide, start by making short one-reel films expressing simple ideas or stories, the less complex the better. As exercises in film making, they should have continuity—a beginning, a middle, and an end; a kid building with

blocks, a traffic cop directing rush-hour traffic, a child opening his Christmas presents, a picnic, etc.

Master the art of the one-reeler before taking on more ambitious projects. Later, the choice is yours; you can do everything from a documentary on the growth of your children to a remake of *Gone with the Wind*. Good luck.

generally will accept a time change without the time-honored fade-out-fade-in device. The less sophisticated audiences of D. W. Griffith's time required them.

The best teachers are the films themselves. Much can be learned if one watches a major movie five or six times. One is usually caught up in the plot during the first few viewings, but after that it is easy to observe the techniques used by the cinema photographer, the director, the editor, the lighting director, and the music composer. Since the 8mm film maker usually fills all of these positions, he can learn a great deal which will be applicable to his own productions. Note the camera angles, and how they enhance the action; note the lighting, and the way in which it adds to the mood of interior scenes. Keep track of the cutting in individual sequences to acertain how the film editor created continuity, and make note of how many separate shots were necessary to accomplish this. Try *consciously* to relate the music to the picture so that you too may learn how to point up action, create suspense, and enhance the unconscious emotional quotient of your films through the use of music.

Much of the knowledge you acquire with this method is applicable to all kinds of films, be they vacation travelogues, documentaries, or ambitious full-length dramas. Film language is the same, regardless of film content. The prime purpose is to communicate an idea, a story or a descriptive essay.

Since most films consist of a series of short individual sequences, by experimenting with simple story-telling films you will learn much of what is involved in the production of these sequences. In the process of editing a short film of four or five sequences, you will discover how to shoot for editing, how to make certain you have sufficient *footage* (exposed film) for the *cutaways, the inserts, the closeups,* etc. (described later).

So, using this book as a guide, start by making short one-reel films expressing simple ideas or stories, the less complex the better. As exercises in film making, they should have continuity—a beginning, a middle, and an end; a kid building with

blocks, a traffic cop directing rush-hour traffic, a child opening his Christmas presents, a picnic, etc.

Master the art of the one-reeler before taking on more ambitious projects. Later, the choice is yours; you can do everything from a documentary on the growth of your children to a remake of *Gone with the Wind*. Good luck.

I

EQUIPMENT

Chapter 1

THE WORLD OF 8mm

THE thirty-dollar Kodak Instamatic M22 Super-8 motion picture camera and its dynamic second cousin, the five-thousand-dollar Eclair NPR, have a lot in common. They both work according to the same principles and require, in order to function:

1. A lens to convey the image to the film.

2. A means to determine what the camera is seeing.

3. A diaphragm or iris to control the amount of light passing through the lens.

4. A shutter to "freeze" the image onto the film.

5. A means to store and propel (at a fixed rate) the film through the camera.

6. A claw or similar device to pull the film down, a frame at a time, and hold it momentarily at the gate during exposure.

The price one pays for a motion-picture camera is determined solely by the convenience, the precision, and the degree of efficiency with which these six functions are performed.

The ultrasophisticated Eclair NPR is a miracle of precise engineering and design. However, the shy little Kodak M22 is an even greater miracle. An economic miracle. Movies, for a measly thirty bucks. Eisenstein could have made *Battleship Potemkin* with such a camera. Griffith, for his thirty dollars, could have shot *Birth of a Nation.* It follows, then, that a motion picture is not only a product of the camera. It is the creative effort of a human being, who is not only adept at using cinematic hardware but, even more important, is capable of transposing his vision onto film.

Film

There are four types of 8mm film* for which cameras are available. They are Standard-8, Super-8, Double-Super-8, and Single-8.

Standard-8

Currently, with the exception of a few Russian cameras, no one is manufacturing cameras to accept Standard-8 film. (In the United States Standard-8 is available only secondhand.) Standard-8 is actually 16mm wide, with perforations on both edges. Half the width of the film is exposed, and at the end of the 25-foot run, the reel of half-exposed film is turned around and the other half is exposed. After processing, the film is split down the center, and then the two strips are cemented together end to end to give you 50 feet of continuous film. From its beginnings in the 1930's until the advent of Super-8 in 1965, Standard-8 was the basic tool of the amateur. Its only competition was the French 9.5mm magazine-load camera, first produced in 1924 and still being manufactured by Pathé France, but of limited distribution outside that country.

The main disadvantage of the Standard-8 gauge was its small picture area. Because of large perforations, less than half of the

*Eight millimeters, or approximately three-eighths inch, is a measurement that applies to the total width of the film.

total film width was utilized for picture. This resulted in a wasteful use of film area, and somewhat inferior quality on the screen (the larger the film area, the greater the image quality on the screen). However, with today's superior film emulsions, the Standard-8 film is quite capable of producing acceptable images.

The Standard-8 reel must be hand-loaded into the camera, and great care must be taken at the end of the first run (when the reel is reversed and rethreaded into the camera to expose the second side) so that the film is not fogged outside the camera. A camera should never be loaded in bright sunlight.

Standard-8 runs through the camera at 16 frames per second, as opposed to the Super-8, which runs at 18 frames per second and therefore gives a bonus of almost a full minute's running time per 50-foot load, at a small decrease in quality. Moreover, many Standard-8 cameras had a backwind capability, a feature which is only partially available today, on a few Super-8's.

For today's amateur film-maker, Standard-8 has one more advantage over Super-8 and Single-8: initial cost. Thousands of used Standard-8 cameras are available at extremely low prices— in most cases under fifty dollars. Almost every camera store has accepted at least a few in trade toward the new Super-8's. Actually, in some areas, they are a glut on the market. As for projectors, many Super-8 machines will also accept Standard-8.

In the late 1950's and early 1960's a great number of Standard-8 cameras were manufactured with many of the same advanced features found in the most expensive Super-8's of today (see buying guide, Chapter 3). A note of warning: A used precision instrument, such as a camera, should be purchased only from a reliable dealer who is willing to guarantee its performance for a reasonable length of time (two weeks to a month).

Super-8

The "Jolly Yellow Giant," as Kodak is known in the trade, instituted the Super-8 revolution in 1965. The convenient little plastic film cartridge has since swept the marketplace. Most of

the amateur cameras being made today are designed around it.

The Super-8 cartridge has, sealed within it, 50 feet of single-track sprocketed film. Its gain in total picture area over Standard-8 is due to smaller sprocket holes, allowing a greater area for picture. This results in somewhat improved image quality. As already noted, the filming speed for the Super-8 is 18 frames per second, as opposed to the 16 frames per second offered by Standard-8 (both are normal running speeds for corresponding projectors). This results in a very small increase in shutter speed and a slight improvement in the smoothness of action. Loading the Super-8 cartridge into the camera is totally idiotproof. A used cartridge can be removed and a new one inserted in less than ten seconds. Color film is of the indoor type (type A or B). When the color magazine is inserted, it automatically cues a daylight conversion filter to remain in front of the film. Black-and-white magazines, on the other hand, cue out the conversion filter. When you are shooting indoors under tungsten light (see Chapter 9, either a key on the camera light or a manual key or switch accomplishes the same thing.

Film speed ratings (see Chapter 6) are automatically transferred to the camera by notches cut into the cartridge.

An almost foolproof system, which works smoothly with a minimum of fuss, the Super-8 format has a lot to recommend it.

Single-8

Though Kodak has been highly successful with the development of the Super-8 system, it has not been entirely victorious. There is one manufacturer who has not climbed onto the Super-8 bandwagon. Japan's Fujica Camera Company has developed, concurrently with Kodak's development of the Super-8 system, a system of its own: Single-8. It is the contention of this writer that the Single-8 system is in many respects superior. The wide acceptance of the Super-8 cartridge by the camera industry, I am sure, is due in part to Eastman Kodak's power in the

marketplace. As previously mentioned, the overwhelming majority of cameras in the 8mm gauge are Super-8's.

In comparing the two cartridge systems, we find an almost total lack of versatility in the Super-8 cartridge as opposed to the Single-8.

The Fujica system, for example, is capable of total backwind, enabling the photographer to make lap dissolves, double exposures, superimposed titles, and other effects in the camera. Except for a few brands of Super-8 cameras which allow a limited and costly backwind capability, this feature is not generally available with the Super-8 cartridge. Single-8 also allows the manufacturers to design precision pressure plates for cameras. The pressure plate is a device which holds and positions the film in the focal plane. Too much pressure can cause scratches, and worse, on the film base. Too little pressure can result in the film's being slightly out of the focal plane: a disaster. The Super-8 cartridge, however, has its own built-in pressure plate. This presents an interesting engineering problem because we are dealing here with macroscopic tolerance, which must be incorporated into a cheap plastic cassette. Somehow it works, but I have more faith in the Single-8 "cheap plastic cassette," which does *not* require these precision tolerances, not having a built-in pressure plate.

Another advantage of the Single-8 system involves its future potential relative to single-system sound. It is considered totally impossible to design a sound-on-film camera around the Super-8 cartridge. The Single-8 design, however, has a future single-system sound-on-film capability because of its lack of a built-in pressure plate. The cartridge can be placed almost anywhere in the camera to allow the required 18-frame lead necessary to smooth out the intermittent movement of the film as it is clawed past the film gate. Sound heads require a smooth, consistent movement of the film over them.

Though it is a rare occurrence, the Super-8 cartridge, because of its design, has a greater tendency to jam than does its Single-8 cousin.

Single-8 film gauge, image size, and sprocket holes are exactly *the same as Super-8,* and totally compatible in all Super-8 projectors. Fuji film, made by Fujica for the Single-8 cartridge, is on a super-thin, super-tough polyester base of mylar. The film will not break or tear. However, it does have a slight tendency to stretch and is not as widely available for travelers. Another slight annoyance is the inability of the Single-8 polyester film to take to cement splicing. At the moment, it can only be joined by the tape-splicing method. On the plus side, however, is the fact that because of its extremely thin base, 600 feet of Single-8 film will fit onto a 400-foot projector reel.

Fujica makes an interesting line of Single-8 cameras, as do Honeywell and a few others. Although there is no comparison with the variety of Super-8 equipment available, the Single-8 has managed to touch all the bases, or at least most of them.

Fuji film for the Single-8 comes in a somewhat limited variety of emulsions, both color and black-and-white and all of a very high quality. The system does not incorporate a conversion filter, and therefore one cannot use the same color film for daylight and tungsten (indoor) light.* ASA film ratings are automatically cued into the camera by notches in the cartridge.

My apologies to the Jolly Yellow Giant, but despite its well-deserved reputation for quality and innovation, I think the legendary Kodak behemoth has blown it. Super-8, though it functions very well and is certainly a great improvement over the old Standard-8, comes out second best to the Single-8 system. The Fuji-sponsored underdog is more versatile and has a greater potential in terms of future camera design.

Double-Super-8

Double-Super-8 comes in 100-foot daylight-loading reels of 16mm stock with Super-8 perforations on both edges. The film is exposed over half its width; then at the end of the first run, the reel is flopped and run through the çamera a second time to expose the remaining half. After processing, the film is slit down

*External conversion filters, however, are available. See Filter Chart in the Appendix.

the center by the processor and the two ends are spliced together, thereby providing 200 feet of continuous-run Super-8, a total of 13 minutes and 20 seconds of screen time at 18 frames per second. Double-Super-8 is professionally oriented. Cameras built to take this film are generally close relatives of the more professional 16mm equipment. In addition to other professional features, these cameras have a backwind capability enabling them to make lap dissolves, superimposed titles, and other effects. Because of the extended filming time, there is less possibility of long scenes' being broken up because the film has run out.

The image size and the sprocketing are exactly the same as for Super-8 and Single-8.

As for the disadvantages, the cameras are heavier and bulkier. Spool loading is more time consuming than cartridge loading, and care must be taken to prevent edge fogging when you are loading and reloading.

Among the cameras available for Double-Super-8 is the unique Honeywell Elmo Trifilmatic, which not only accepts 100-foot double reels, but also takes interchangeable film magazine backs which accept Single-8 and Super-8 (magazine).

From this point on we will refrain from differentiating between Super-8, Standard-8, Single-8, and Double-Super-8; we will refer to them all (except in a few specific instances) as S-8.

A camera-buying guide (Chapter 3) describes in detail the many S-8 camera features available.

Running Speeds

Motion pictures "work" because of a peculiar quirk of the human eye we call "persistence of vision." The eye will, for a brief interval, retain an image even after the stimulus or source of the image disappears. If, for example, we watch a single frame of motion-picture film projected onto a screen, our eyes will retain the image momentarily after the picture leaves the screen. If during this interval of image retention a second frame of film

is projected, the two will seem to flow together. Now try it with 18 pictures per second!

Eighteen frames a second is the standard speed at which film is exposed and projected in the S-8 (except for Standard-8, which is 16 frames per second). At 18 frames per second, subject movements will appear normal. However, if the camera is "undercranked" and run at 12 frames per second and then the film is projected at 18 frames per second, the action will appear jerky and speeded up on the screen. The old silent movies weren't shot that way, they're just projected now at too fast a speed. Which brings us to an interesting tale.

Toward the end of the silent era, in the late 1920's, a large number of unscrupulous theater owners ordered their projectionists to speed up projection to about 20 frames per second. The films, running faster, would thus enable the theater to squeeze in an extra daily showing. The cameramen (who in those days were hand-cranking their cameras very expertly at 16 frames per second), upon hearing of this abomination, increased their cranking speed. The theater owners increased theirs again, and the race was on! There was no significant victory on either side, however, because shortly thereafter the sound era began, and it was necessary, for technical reasons, to standardize all theatrical sound-filming at 24 frames per second.

"Slow motion" is achieved by overcranking, or running the camera at a faster rate than standard. A film shot at 36 frames per second and projected at the S-8 rate of 18 frames per second will appear to be in slow motion. The faster the camera speed, the slower the motion, and, once again, vice versa.

Viewfinders

All S-8 cameras have one of two types of viewfinders: (1) the nonreflex (positive or Galilean types); (2) the reflex-through-the-lens system.

Less expensive cameras use the nonreflex type of viewfinder.

This type of viewfinder, which was standard until not too many years ago, is adequate for nonzoom lenses.

The reflex finder is today's standard for viewing and focusing. With this viewing system, the photographer actually sees the subject through the camera lens, pretty much as the film sees it. Reflex viewing is totally free of the problem of parallax. Parallax exists when the viewfinder and the lens are separated (as with all nonreflex viewfinders) and therefore view the subject from slightly different angles. This doesn't present much of a problem with long shots, but parallax error can raise hell with closeups. Some of the better nonreflex finders on focusing cameras, however, are "parallax corrected," ensuring against cut-off heads and similar amputations.

Through the lens the reflex finders operate by use of a "beam splitter"—a prism or a partially reflective mirror which diverts a portion of the light—transmitted through the lens into a finder system. In a well-designed system, the portion of light that is diverted through the viewfinder is less than one-third of the total passing through the lens (affecting the final exposure less than one-half stop) but it is sufficient light to create a bright viewfinder image. In most cameras, the beam splitter is placed in front of the lens diaphragm, so that the eye always sees a full aperture image, regardless of the f-stop set into the lens at the time. You focus by referring to a small area in the center of the viewfinder screen, which usually consists of a ground-glass circle, a microprism grid, or a split-image range finder. These are all satisfactory methods for focusing, although far from ideal.

Currently, Sankyo has available, as part of its viewfinder, a two-window range finder of the coincidence type (comparable to that of the Leica still camera), which is not only highly accurate but extremely easy to use. Other manufacturers are sure to pick up on this system, and I strongly suspect that within a few years it will become the standard focusing mechanism for the S-8 camera. Bell and Howell, on their Focusmatic cameras, solve the problem through the use of a Rube Goldberg type of device based on the pendulum principle.

Actually, one of the greatest supplementary aids to focusing is a plain, old-fashioned distance scale engraved on the lens barrel or elsewhere. A few manufacturers have even included click stops at various focus settings. The Yashica, for example, has three such click stops.

Present in the viewfinder on most S-8's will be at least one or more of the following indicators; f-stop, end-of-film warning, film-transport indicator (or safe-run indicator).

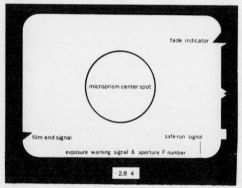

Viewfinder for Minolta D-10.

Image size in the reflex finder varies from camera to camera and is directly related to image brightness. The smaller the size the brighter the image, and vice versa.

One major exception to the above rule is the Beaulieu, which uses a rotating mirror instead of the usual beam splitter to convey the image through the viewfinder. Thus, the eye through the viewfinder receives the same amount of light received by the film. Focusing can be accomplished across the full viewfinder screen (just as with a Nikon), and the image magnification is an incredible 27x! This camera has the brightest, largest, most luminous reflex-viewing screen of all, and is a totally professional piece of equipment. It is also, in S-8 terms, very expensive.

Chapter 2

THE LENS

TWENTY-five years ago, before computers were used for just about everything, the thought of designing some of today's lenses would have driven the average lens designer either up the wall or to drink. Computers, of course, are responsible in this day and age for vast improvements in what is now called our life-style. They nail down our unpaid traffic tickets, send us incorrect bills, and even go so far as to seek out, for some of us, totally incompatible mates.

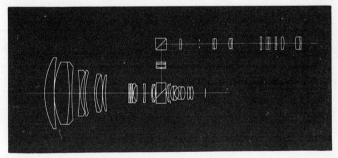

Lens system for the Canon 518.

Now, getting back to the average lens designer: the computer has helped him create miracles of optical design. Not only was

that zoom lens you are fondling unavailable twenty-five years ago, its high quality, range, maximum aperture, and low price were barely conceivable.

All photographic lenses are categorized according to aperture, and focal length.

Aperture (F-Stop or Speed)

A lens has an iris or a diaphragm which works like the pupil of the human eye. This iris dilates or contracts according to the amount of light present: a small opening for brightly lit subjects, a larger opening for dimly lit subjects. To put it another way, the brighter the light, the smaller the lens opening.

Most S-8 cameras have an *"automatic* diaphragm," which, like the human eye, *automatically* opens and closes according to the amount of light present. This adjustment is accomplished through the use of an electronic light-sensitive device called a "photoelectric cell." There are, however, inexpensive S-8 cameras without exposure automation. Here, lens openings must be decided upon and set by hand as on more sophisticated movie and still cameras.

The term "f-stop" relates to a designation common to all photographic lenses. As the lens diaphragm is contracted, or "stopped down" (either manually or electronically), the f-stop designation changes. The number grows as the opening decreases. Following is a typical sequence of f-stop designations found on most cameras. Except for f/1.8, each succeeding f-stop transmits exactly half the amount of light as the one preceding it: f/1.4, f/1.8, f/2, f/2.8, f/4, f/5.6, f/8, f/11, f/16, f/22 (f/1.8, for all practical purposes, is known as a "half stop").

In photographic parlance, to change to a smaller diaphragm opening is to "stop down." To change a larger opening is to "open up." Thus, if you are changing the diaphragm setting from f/2.8 to f/5.6, you are stopping down two stops. Conversely, if you change from f/16 to f/4, you are opening up four stops . . . simple (see page 195).

Focal Length

Focal length is usually expressed in millimeters. It is measured from the optical center of a lens to the film plane of the camera. Long lenses are known as "telephoto lenses" (incorrectly called "telescopic lenses"), and short lenses are known as "wide-angle lenses." As will be noted elsewhere in this book, long or telephoto lenses tend to flatten out perspective, and short or wide-angle lenses present an exaggerated perspective (long noses, for example). Between the two extremes is a focal length that is called "normal." A normal-focal-length lens is one which most closely approximates the perspective perceived by the human eye. For some reason or other, 15mm has more or less been established as the normal focal length for S-8, however, if the reader is considering an inexpensive single-focal-length lens camera, I advise him to make sure the lens is shorter than 12.5mm.

Normal Lenses

The term "normal" when applied to a lens focal length means that its resultant perspective relationships are approximately the same as those of the human eye. For reasons that escape me completely, the 12.5mm to 15mm focal lengths are considered normal for the S-8 format. Actually, "normal" is more closely approximated in the range of focal lengths between 8mm and 10mm.

The term itself dictates its use. A normal focal length is a standard from which deviation is possible. Everything shorter is wide angle, and everything longer is telephoto. The normal focal length is used when no aesthetic or practical reason exists for not using it. It creates a perspective that is close to that of the human eye and therefore unobtrusive and "normal." Though camera shake is less likely than with telephoto lenses, care must be taken when you are "hand-holding" a normal lens shot.

Telephoto Lenses

The telephoto lens* (or telephoto position on a zoom lens), because of its narrow field of view, tends to bring far objects closer, much as does a telescope. The above statement, of course, is an oversimplification in terms of the practical uses of the telephoto, and if the movie maker restricts his use of the telephoto simply to "bringing far objects closer" he is short-changing himself. With the S-8 camera, any focal length exceeding 15mm is considered a telephoto lens.

Perspective is controlled in photography by relative focal length. By relative, we mean in relation to distance and film size. For example, a 50mm lens on a 2 1/4 x 2 1/4 Hasselblad camera is considered an extreme wide angle. The same focal length on an S-8 camera is considered to be quite a long telephoto.

The flattened perspective of a telephoto shot has the tendency to compress size relationships. If, for example, we were to photograph a car approaching the camera from a starting position of 100 feet with a 7mm focal length, by the time it had moved 50 feet, its image size on the film would be doubled. At 50 feet the car is twice the size it was at 100 feet because it has come half the distance.

Same car, same speed of approach, different focal length; this time we switch to a 70mm focal length. We want to start with the car the same size as it appeared in the first shot. To do this we now must be 1,000 feet from the starting point of the car. We have multiplied the initial focal length by ten; therefore we must also multiply the original subject to camera distance by the same factor in order to get the same initial image size. As the car approaches the camera we find its relative increase in size to be slight and it appears to be approaching much more slowly than before. In fact, when it has rolled 50 feet as in the previous example, its size has hardly changed at all. In the first example, using a 7mm focal length, the car doubled its size in 50 feet because that was half the distance to the camera. In the second

*The term "telephoto lens" within the context of this book is to be interchangeable with the term "long focal length." For all practical purposes they have the same meaning.

An example of flattened perspective. The lens used was equal to an S-8 equivalent of 50mm. Notice that the cars in the background appear to be almost the same size as the cars in the foreground.

example, using a 70mm focal length, even though its initial size was the same the car would have to roll 500 feet, half the distance to the camera, before it doubled its image size. This size-distance-perspective relationship holds true all up and down the focal length scale.

Telephoto lenses have many interesting and strange qualities. Skylines tend to appear as unified masses. Near objects are foreshortened and far ones magnified. Sunsets are totally fantasized, the sun becoming a monstrously huge orange ball with small figures silhouetted in front of it. Seascapes are compressed, the breakers more violent, the following waves larger, more massive than life. (Try it in slow motion with a surfer.) Size relationships are distorted, contracted, compressed. Distant objects, though relatively large on the film, have a remoteness about them. Though seen through the telephoto, they still seem unapproachable.

This combination of long focal length and narrow depth-of-

field (see Chapter 4, "Focusing") tends to isolate the subject against its background.

The ultralong telephoto image also seems to isolate the audience from the action, as if it were outside looking in. It engenders a feeling of objectivity. The audience eye is somehow cued to the fact that it is watching an action that it really isn't involved in. Regardless of the size of the magnified image on the film, the viewer remains unconsciously aware of the fact that he is viewing the subject from a distance. That this is an unconscious reaction presents the movie maker with a valuable psychological tool.

A lens will magnify camera movement, and shake to the same extent that it magnifies the subject, because a small movement at the camera results in a large movement out there. The best way to overcome this problem is to use a tripod. The next best way is to prop or clamp the camera onto a solid structure: a fencepost, a tree, a chair, etc. When all else fails, get your elbows tight to your body, assume a wide-legged stance, jam the camera against your forehead, and hope for the best. These safeguards are applicable to all focal lengths, but become very critical with focal lengths over 25mm.

There has been much talk over the last ten years concerning aesthetic freedom, and how it is enhanced by the use of the "hand-held camera." It has become a cult. However, the hand-held camera, though it has been a cinematic tool for at least ten times as long as it's been a cult, is not the beginning and end of cinema photography. It has its place and its function, but its place is certainly not with telephoto lenses, at least not without a considerable amount of practice in holding the camera steady.

It is desirable, but not absolutely necessary that a tripod be of heavy sturdy construction. A small lightweight pocket tripod, however, might be preferred because of its portability. The camera, once mounted on such a tripod, must be handled with great care, and a remote electrical release or cable release should be used to make it even easier. A good-sized camera clamp is another handy device, as is a shoulder gun stock.

An example of the unobtrusive telephoto.

Panning and tilting with telephoto lenses also requires great care. The slightest irregularity in movement is of course magnified. When possible, it sometimes pays to overcrank a telepan (or tilt) in order to smooth out the bumps and shakes. The previously mentioned lightweight pocket tripod is a total loss for tilts and pans. What is needed is a reasonably sturdy tripod with a pan head.

Moderately long focal lengths of from 15mm to 25mm are particularly useful for filming closeups, as they enable the camera to remain at a comfortable distance from the subject. The slight perspective compression inherent in the moderate telephoto tends to enhance and flatter, by flattening long noses, pointy chins, etc.

S-8 lenses of over 40mm are extreme telephotos. For those readers familiar with 35mm still cameras, an S-8 focal length of 60mm is about equal in terms of magnification to a 425mm lens

on a 35mm camera. A 70mm setting on an S-8 zoom is roughly equal to 500mm on a 35mm camera. Quite heavy artillery. It must be reiterated that a tripod or some other means of securing the camera is an absolute necessity when you are using long focal lengths such as these.

Wide Angle

Short-focal-length lenses provide a function that is opposite to that of telephoto lenses. Perspective is widened and expanded, sometimes to the point of obvious distortion. Objects close to the camera tend to appear elongated and larger in comparison to objects farther away. A low-angle shot with a wide-angle lens is dramatically distorted. Shooting up at someone from the ground can create an imposing, looming monster. The camera tilted up at a building results in a picture in which the structure seems to be reaching for the sky—its lines converging toward the top. The short focal length causes interiors to appear to be larger, distances appear to be greater, and foreground images can be distorted perspectivewise to overwhelm objects behind them. A head can be as large as the house behind it, a closeup pencil can loom taller than the skyscraper in the near background. All of these effects are further enhanced by the extreme depth-of-field inherent in wide-angle lenses. (See Chapter 4.)

An important function of the short focal length, of course, is its use in tight situations where it is impossible to back up without hitting a wall or falling into a ditch. But its use should certainly not be restricted to such mundane purposes. The wide angle when used with imagination can create magic, which is also a reason why it should not be overused.

Short focal lengths present few problems in terms of camera shake if reasonable care is taken.

Of course, most of the above would appear to be academic in the light of the fact that there are very few currently available S-8 cameras equipped with a true wide-angle lens.* S-8 zoom lenses are usually limited to 7.5mm with a few zooming down to 7mm.

*The Beaulieu 4008ZM S-8 has the added facility of accepting "C" mount lenses. There are some superb wide angle optics available in C mounts. There are also many older Standard-8 cameras which accept interchangeable lenses.

A wide-angle lens used to obtain a shot that would otherwise have been impossible. The lens was the S-8 equivalent of a 5mm. Currently, a wide-angle conversion lens would be necessary to achieve this short a focal length with an S-8 zoom.

These focal lengths can hardly be termed wide angle,* although possibly one might consider 7mm moderately wide. I would suspect that one reason for this discrepancy is that lens manufacturers find it almost impossible to design a quality zoom lens which includes a really short focal length. It is an overwhelming design problem, considering the fantastic zoom ratios that are so popular today. Perhaps some day we may have a high-quality zoom lens which will hold focus from 3mm to 60mm.

Wide-Angle Converters

Meanwhile, we have wide-angle converters. They share some common defects, such as barrel distortion (the tendency for the straight lines at the edge of the subject to curve out). But all in all they work well and should certainly do until the real thing comes along. Wide-angle converters are attached to the front of the

*Those who accept 15mm as "normal" for the S-8 format will no doubt dispute this.

camera lens and to varying degrees increase the angle of view considerably.

Zoom Lenses

The one great fault I find with zoom lenses is that they are called zoom lenses. Perhaps if they were given another descriptive name, such as "variable focal length lenses," we of the amateur-film audience might not be driven to migraine and myopia by the constant zooming projected on many amateur screens. (More about that in a later chapter.) The term "variable focal length" is totally descriptive of the zoom lens function. "Variable focal length" means that a zoom lens can be set to any focal length within the limits of the lens's zoom ratio. A 5 to 1 zoom ratio, one that zooms from 8mm to 40mm ($40 \div 8 = 5$), for example, can be set at an infinite number of focal lengths between 8mm and 40mm. It can also "zoom," smoothly and in focus, all the way from wide angle to telephoto. The advantage over single-focal-length lenses is obvious. The minimum alternative to a zoom would be three lenses: a telephoto lens, a normal lens, and a wide-angle lens mounted on a turret. Many professionals still cling to the three-lens turret configuration. They do so for one major reason: no zoom lens, despite its cost, can compare in optical quality to a good single-focal-length lens. (A few, however, come mighty close.)

The typical modern zoom lens has twelve or more lens elements, and its design presents almost insoluble problems of alignment and a hundred assorted aberrations of one kind or another. The zoom lens ends up being an optical compromise. But it works! It works well, and for the life of me I can't understand how any of them can sell for under a thousand bucks.

Chapter 3

CAMERA-BUYING GUIDE

THE S-8 film gauge is quite capable of producing good picture quality, far better in terms of clarity, sharpness, and color accuracy than, for example, the television tube. A projected S-8 film will resolve far more detail than a TV picture of equal size. However, S-8 is currently no competition in these departments for the larger 16mm and 35mm gauges. Its image

Motion-picture film gauges, relative size, including sound tracks.

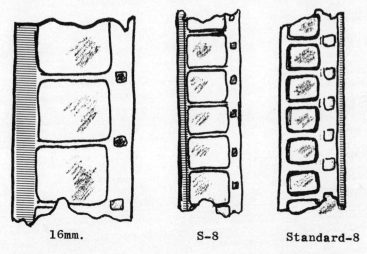

16mm. S-8 Standard-8

size is just too small to tolerate the great magnification needed for large, auditorium-size screen projection. With that exception, an S-8 camera can do almost anything its big cousin can do.

The purchase of an S-8 camera is much the same in terms of choice as is the purchase of a car. A Ford will get you there just as quickly, and these days almost as comfortably, as a Cadillac. Furthermore, just as power brakes and power steering and power windows and automatic transmission and electric door locks, etc., cost extra on an automobile, so do power zoom and autofade and variable shutter and slow motion and macrocapability cost extra on an S-8 movie camera. Nice things to have, but not entirely necessary to get you where you want to go.

Above all, avoid the trap of equipment collecting for its own sake. This is a very real disease with many photographic hobbyists. Cameras and other photo gear become toys for them to collect and tinker with.

Generally speaking, the average photographic dealer, unlike the average used-car dealer, is an honest, God-fearing family man whom you can trust, certainly as far as you can throw him (not too much farther though—let's not get carried away). His situation is pretty cut and dried, as the list price markup on photographic equipment hovers around 40 percent, and that represents his horizon. Both he and I and every pro in the business know something that you might not know; no one, absolutely no one, really has to pay list price for a camera in these United States. It is just not required of anyone to pay what is laughingly called the "manufacturer's suggested retail price." Of course if you want to take the manufacturers' "suggestion," I'm sure that your dealer will be happy to accommodate you. However, I suggest you deal on a 10 to 15 percent discount. More than that is being greedy (unless you are a very good customer, and then 20 percent is tops). Your dealer has to live also, and with his overhead, a 20 to 30 percent markup is fair.

On the other hand, watch out for FANTASTIC DISCOUNTS! AMAZING LOW PRICES! GOING OUT OF BUSINESS,

MUST VACATE, BUY NOW! and any camera that sells new within 10 percent of its wholesale price (more than 30 percent off list price). At best, it is a discontinued model; at worst, it "fell off a truck." In between, you have cameras which somehow side-tracked their national distributers, and thus might have invalid, or otherwise useless guarantees.

Avoid as if they were plague ridden the many "going out of business" shops of the type which currently line the Times Square area in New York and the main streets of many major cities. They sell everything from Turkish rugs to TV sets. I have great admiration for the owners of these establishments, as they show great artistry in bilking the public, and I just can't knock talent of any kind. Nevertheless, beware. What you see in their window displays, is not always what you walk home with.

A word also about the guy who approaches you with a $750 Leicina which he has to sell for a lousy two hundred clams because his mother is in the hospital in Azusa and needs an operation. It's a stolen camera! Now, despite the moral consideration, which I trust you've already considered, the chances are good that this camera has been *reported* stolen. If it weren't stolen, the dutiful son probably would have hocked it. He daren't. Pawnshops in many states are required to report regularly to the police the serial numbers of all cameras taken in pawn along with the name and address of the pawner. But let's go on the assumption that the guy convinces you and you fall for the mother story. Six months or a year later, you're going to be somewhat chagrined when you go to pick up your camera at the repair shop and find that an insurance company has claimed it. Reputable repair shops refer, regularly, to insurance company lists of stolen cameras.

When buying a used camera from a dealer, always insist on either a guarantee or a tryout period. A good test is *almost* as good as a guarantee. If the camera is no good, you've blown the price of a couple of rolls of film, and that's all.

Under $100

Most cameras in the lower end of this price range come equipped with fixed-focus, single-focal-length (nonzoom) lenses. Generally, these are very good lenses, in terms of sharpness, etc. Inexpensive single-focal-length lenses tend to be at least the equal in quality of zoom lenses costing three and four times as much.

A number of low-priced cameras have zoom lenses with ratios of 2 to 1, or 3 to 1. These rudimentary zoom lenses do not represent the epitome of optical quality by a long shot. If you decide to purchase this type of inexpensive fixed-focus zoom camera, make sure that there is an automatic focus-shift mechanism, which shifts the focus into different ranges as you zoom. The reason for this is that depth of field differs radically relative to the focal length of a zoom lens. So, for example, a factory-set focusing distance of 15 feet for the 12.5mm zoom setting might be ideal (depth of field at f/1.8, 8 feet to infinity). But the same 15-foot setting when the lens is wide open and zoomed out to 25mm will throw everything beyond 20 feet out of focus. An automatic focus shift is necessary to compensate and, in the above case, shift the focus setting to about 70 feet (depth of field at f/1.8, 30 feet to infinity). I would strongly advise against buying a fixed-focus zoom camera without this facility.

A few of the *focusing* zoom cameras in this price range are very cheaply made, and the microprism grids they sport in their viewfinders are practically worthless. Make *sure* you can focus the camera before you buy it.

Ask your dealer to let you view through a more expensive camera (Yashica, Canon, Minolta, Eumig, etc.), and compare the relative ease of focusing. The lower-priced camera might not focus as easily as its more expensive cousin, but you will have some basis for comparison.

With very few exceptions, most cameras in this price range have some means of exposure automation. In most cases this will

be controlled by a meter behind the lens. A few cameras at the low end of the price scale have meter cells mounted on the front of the camera. Whichever is the case, it is important that the camera have some kind of exposure readout, preferably in the finder. Why trust an automated camera which keeps secret the f-stop it has decided to use?

A few cameras available at these prices, without exposure automation, should not be overlooked as possible purchases just because of the lack of this much-vaunted feature. Actually, many of the truly professional 16mm and 35mm motion-picture cameras share this lack. For a couple of bucks you can buy a small exposure meter and set your own f-stops.

The danger here is one of the more deadly of the seven sins, greed. Everything has to be paid for in some way or other, and a camera costing $80 or $90, with a high-ratio, focusing zoom and every gimmick and feature in the catalogue, is more than likely paying for all its goodies with low quality. You just can't have everything, unless you're willing to pay for it with real money. It follows then, that you have to ask yourself if you really need *everything*.

For cameras costing under $50 the best bet, by far, is to search out a good used Standard-8. For example, a 1960-1965 used Bolex, in good shape, with a three-lens turret, featuring excellent optics and true slow motion (and the hardy, high quality of a 1932 Mack truck), can be picked up for about $40. If it is in good running order, such a camera is the equal, except for the smaller image size and lack of automation, to Super-8's, and Single-8's selling for three times the price, or more.

From $100 to $200

All of the cameras in this price bracket have zoom lenses and, with the exception of a few 2 to 1 fixed-focus zooms at the lower end, all come equipped with focusing zoom lenses ranging from 3 to 1 all the way to 8 to 1. General quality is quite good as far as

camera bodies are concerned, but I would tend to be somewhat skeptical concerning the quality of any camera with a lens having a zoom ratio of more than 6 to 1. Quality in the higher zoom ratios is expensive to produce, and at these prices something's got to give. It's going to be either a poorly constructed camera or a lousy lens, or both. Of course there are exceptions, but they are few indeed. Watch out for those $120 cameras with 8 to 1 zoom lenses. Of course there's always the possibility that you might be lucky. Check such cameras out carefully.

There is currently only one camera in the under $100 price range which has built-in sound synchronizing capabilities. In the $100 to $200 bracket, however, there are a few. These are cameras equipped with pulse generators, which are capable of transmitting synchronized pulse signals to a tape recorder, which records them on a second track running parallel to the audio signal (see Chapter 18). This type of sound-syncing equipment is relatively simple and is inexpensive to design into existing camera models. Currently you can purchase a complete system, including camera, tape recorder, and microphone. If you prefer, purchase just the camera and add the rest of the equipment later.

Most of the cameras being sold in the amateur market today carry a $100 to $200 price tag. At this price, there is a large variety available and most of the important manufacturers are represented. Shop carefully, as there is a lot to choose from.

XL55 and XL33

The Kodak XL55 and XL33 Super-8 cameras, through the use of a few ingenious expediencies, are capable of exposing film at light levels roughly one-third of those required by most other S-8 cameras (a feature that requires the listing of this camera in a separate category).

The stop-and-a-half of exposure gain is brought about by: (1) a 230° shutter instead of the conventional 165° shutter, which reduces the effective shutter speed from one-fortieth of a second

to about one-twenty-fifth of a second, thus permitting about 40 percent more light to reach the film; (2) an f/1.2 lens, which is one-half stop or 50 percent faster than its nearest competitor, the f/1.4 lens; (3) a separate (parallax-corrected) viewfinder, which unlike the typical split-beam-type reflex finder, does not split, for viewing purposes, any light off the main optical system, thus conserving an additional 20 percent to 35 percent of usable light intensity for film exposure purposes; (4) a double-vane exposure control, rare in cameras of this price range, is good for another few percentage points.

The only drawback to all of this is the slight decrease in image sharpness brought about by the decreased shutter speed when you are shooting action and the somewhat limited focal length range of the XL55 zoom lens (9mm to 21mm).

Both the fixed-focus, single-focal-length XL33 and the zoom (XL55) sell for under $200.

$200 Plus

In this price range the sky is the limit. There are zoom ratios all the way up to 12 to 1, macrocapabilities for shooting extreme closeups, filming speeds up to 50 fps,* variable-speed power zooms, radio control, intervalometer time-lapse control, microscope adaptation, strobe synchronization, autofades and lap dissolves, coincident range-finders, Double-Super-8 roll film adaptation, variable shutters, sound-pulse generators, interchangeable lenses, and other goodies.

It is here that we find brand names long associated with high-quality professional still and motion picture equipment: Bolex, Nikon, Leica, Minolta, Yashica, Beaulieu, Canon, Rollei, Zeiss Ikon, and others.

A surprising number of these cameras have features lacking on even the most expensive professional 16mm cameras. A few examples: the *Nizo S-56* features built-in time-lapse capability;

*Frames per second.

the *Elmo Trifilmatic Super 100* accepts Super-8 and Single-8 cartridges in addition to 100-foot rolls of Double-Super-8; the *Canon DS-8* accepts 200-foot rolls of Double-Super-8 and provides running speeds up to 54 fps; the *Beaulieu 4008ZM,* has built-in sync pulse and interchangeable lenses; there are just a few higher-priced Super-8 cameras available with auto lap-dissolve capabilities . . . 90 frames of it; the *Minolta Autopak-8 D10* comes complete with autofade, variable shutter, manual exposure override, *and* over-under compensation; *Leicina* is the Rolls-Royce of Super-8, built to last, with lip-sync pulse capability, time-lapse, and strobe sync; and the *Sankyo Super CM 660* features a highly accurate double-image-conincidence range-finder.

Every conceivable feature and capability is available in this price range, but even more important is the overriding factor of quality in design, construction, and optics. This is not to say that a $200 to $1000 camera is necessarily rugged and trouble-free. The superbly designed professional Beaulieu 4008ZM, for example, is an extremely sensitive instrument and must be treated as such. The Yashica Super 800 Electro, on the other hand, is built to take a tremendous amount of physical abuse, even in Arctic conditions.

It is entirely up to the purchaser to decide which combination of features is important to him. No one camera has them all. Shop carefully, with this in mind.

Camera Controls and Features

The following is a complete listing of just about every feature available on S-8 cameras. Included also is advice on what to demand in terms of quality.

1. Footage Indicator: Some means of informing you of how much film is left in the camera.

2. A Dioptic Adjustment for Reflex Viewfinder: A must, if you

have anything other than 20/20 vision. This is a means of adjusting the reflex viewfinder to your own eyesight. It's a drag to wear glasses while attempting to peer through a small opening in the back of a camera—though of course you can. Adjustment should range 2 1/2 diopters on each side of normal.

3. Electric Power: Two penlight batteries, size AA, are adequate for cameras in the lower price range. If the camera is designed to take AAA batteries, four is the bare minimum. For cameras with power zooms, at least four AA cells are required.

4. Power Zoom: A motorized means of zooming smoothly in either direction, usually accomplished through the use of a conveniently placed rocker switch. A motorized zoom should by no means exclude manual zoom operation.

5. Variable Motorized Zoom Speeds: A means to control zooming speed through the use of either preselected settings or a continuously variable dial.

6. Maximum Aperture: An f/2 is the minimum acceptable.

7. Minimum Focusing Distance (Focusing Lenses): With zoom lens set at shortest focal length, the camera should be capable of focusing, wide open, at four feet or less.

8. Extra Running Speeds: It is nice to have, in addition to the standard S-8 running speed of 18 frames, the additional option of 24 frames per second. This faster speed is useful when you are shooting from automobiles, etc., as overcranking has a tendency to smooth out the bumps. Additional speeds are certainly desirable. The more the merrier. A speed of 36 frames per second is required for *true* slow motion.

9. Reflex Viewing and Focusing: A reflex finder enables one to see the subject through the camera lens. Reflex focusing is

usually accomplished through the use of a microgrid in the viewfinder and should be relatively easy. Before making a decision, check out the microgrid focusing in a few other cameras to establish a basis of comparison. It might also pay to look into the few available split-image focusing systems. Of particular interest is the Sankyo type of two-window range finder currently available—and sure to be copied by other manufacturers. Viewfinder brilliance varies according to image size. Make comparisons in order to find the compromise which best suits you.

10. The Film-Running Indicator and Film-End Indicator: The film-running indicator is a flag or signal in the viewfinder which indicates whether the film is running normally through the camera. The film-end indicator is sometimes incorporated in the running indicator, and nudges you when you've run out of film, which is quite possible to do in a situation where ambient noise has prevented your hearing the change in tone of the camera motor indicating that you're out of film. Certain parties have been known to get carried away and continue shooting on an empty magazine for hours. The little warning flag can be helpful.

11. Film Speed Settings: As will be explained in greater detail later, every film emulsion is rated as to its sensitivity to light. On all Single-8 and Super-8 cartridges there are notches which cue the camera as to the ASA speed (sensitivity rating) of the film contained in the cartridge. A film speed acceptability of less than ASA 160 will exclude the use of some very useful types of "faster" film and will severely limit the camera's capability in relatively dim light situations.

12. Through-the-Lens Metering: The light meter is behind the lens and "sees" the world pretty much as the film does. A few S-8 cameras, for the most part in the lower price ranges, have meters mounted on the front of the camera. Though effective,

these front-mounted meters do not necessarily "read" all the area covered by the lens.

13. Positive-Telescopic-type Viewfinder (on Nonreflex Cameras): Practically all Super-8 nonreflex cameras come equipped with positive-telescopic-type viewfinder lenses. However, some models of Standard-8 cameras come equipped with an inferior Galilean-type optical viewfinder, which is sort of a reverse opera glass. When shopping for a used Standard-8, check your purchase against one of the Kodak M-22 or M-24 cameras, both of which use positive-type optics for viewfinders. If your prospective camera has a Galilean-type viewfinder, the image will have fuzzy edges and the world will appear to be a great distance away.

14. Remote Release: An electrical release to which an extension can be added so that the camera can be run from a distance. This release can sometimes be augmented through the use of radio control.

15. Distance Scale (for Focusing-type Cameras): This is a scale in feet and/or meters, usually engraved on the lens barrel or elsewhere. Such a scale becomes important when you are calculating depth of field (a term that keeps popping up—we deal with it later in detail). A footage scale is, in many situations, a convenient way of setting focus with or without the availability of a focusing viewfinder.

16. Focal-Length Indicator (Zoom Lenses): Even with short-ratio zoom lenses, it is still nice to know where you stand. Focal-length settings are usually engraved on the lens barrel and are indispensable in calculating depth of field.

17. F-stop Indicator: You would figure this to be standard on every camera of whatever type, size, shape, or national origin. It is not. Depth of field is impossible to calculate without f-

stop data. The indicator should be in the viewfinder. However, if we *demanded* an f-stop indicator or readout in cameras in the lower price range, we would have to exclude some otherwise high-quality inexpensive S-8's.

18. Manual Exposure Control (Automatic Diaphragm Cameras): Automatic exposure control devices are not perfect. The tiny cadmium-sulphide (CDS) photoelectric cell found in most automated cameras is programmed to react to the total amount of light striking it. The amount of light on the cell determines its resistance to a current being passed through it. This current controls the automated diaphragm. The tiny CDS cell is extremely sensitive, but it is not human. For example, if you are shooting a relatively dark subject against a light background, let's say a skier, the CDS cell will react to the brilliance of the white snow, and the skier himself will be underexposed. Conversely, if the subject is light against a dark background, say a pretty lady brilliantly lit against a dark wall, the unintelligent meter will include in its calculations the large expanse of dark wall modified only slightly by the brightly lit lady. It will "report" to the diaphragm that on the average things look kind of dim out there, the diaphragm will take the advice, open up, and the resultant picture will show a white, featureless blob in the center of a medium gray wall; in other words, it will be overexposed.

So, it is desirable to have a way of "defeating" the automatic metering system. There are three methods: The first is the *one-stop over-under system*. Some cameras supply a means whereby the exposure can be modified to the extent of one stop over or under the reading of the automatic diaphragm. The control switch by which this is accomplished is sometimes labeled "backlighting" for one-stop *over* exposure and "spotlight" for one-stop *under* exposure. On many cameras, however, it is simply labeled "plus one stop" and "minus one stop." For exposure compensation, we would use "plus one stop" for the skier and "minus one stop" for the

lady. Generally speaking, the one-stop plus or minus method should handle most situations.

A somewhat more professional system found on some cameras is the *exposure lock*; this is a means by which an automated exposure can be locked into the diaphragm control. Once again using the bright lady against the dark background as an example, we would take a close "reading" of her face and then activate the exposure lock. When we pulled back to get our shot, the diaphragm, having been locked on the relatively high light-value of the lady's face, would be unaffected by the relatively low light reflecting from the dark wall. Result: Properly exposed lady against a dark wall.

The totally professional way of controlling autoexposure is *the manual exposure override*. Here is an override method that is perhaps the simplest and the most effective of all. The automatic function of the meter is simply cut out of the circuit and the diaphragm is set manually. You are the boss, and nothing beats that. Cameras without some means of overriding the automatic exposure system are not recommended.

19. Safety Lock and Running Lock: It is a good idea to have a means of locking the trigger which sets the camera rolling, to prevent inadvertent release, that is, a safety lock. A running lock locks the camera in the running, or "on," position.

20. Single-Frame Capability: A facility by which time-lapse photography is made possible. Some cameras come equipped with a mechanical cable release, while others are controlled electrically. There are timing intervalometers available with some cameras which automatically time the single-frame exposures from five per second to less than one per minute. With time-lapse techniques a flower's blooming can be speeded up to a few seconds of screen time.

BUYING-GUIDE CHART

FEATURE	UNDER $100	$100 TO $200	$200 AND OVER
1	X	X	X
2	X	X	X
3	X (E)	X	X (F)
4	O	X	X
5		O	X
6	X	X	X
7	X	X (D)	X (D)
8		O	X
9	O	X (B)	X
10	O	X	X
11	O	X	X
12	O	X	·X (C)
13	X	(B)	NA
14		O	X
15	O	X	X
16	O	X	X
17	O	X	X
18	O	X	X
19	X	X	X
20		O	X
21		O	X
22			O
23	(G)	(A)	(A)
24			O
25			O

Numbers on the left of the chart refer to the listing on the previous pages.

X Controls and features considered standard equipment in their respective price ranges. When purchasing a camera in a specific price range, the buyer should make sure that *most* of the "X"-designated features are present.

O Controls and camera features found on *some* cameras in their respective price ranges. The "O" designation should be of help in the pricing of cameras with special requirements.

NA Not applicable.

A Standard on most Single- and Double-Super-8 cameras in this price range. Found on only a few Super-8 cameras.

B The Kodak XL33 and XL55 feature an excellent positive-type viewfinder with a built-in coincident-type range finder. The XL55 has viewfinder provisions for its zoom lens.

C The Canon-DS8 makes use of a body-mounted meter rather than a behind-the-lens meter.

D Exclusive of macrofocusing.

E Many Standard-8's were made with spring-wound motors.

F Even more power is needed for camera speeds exceeding 36 fps.

G Found on some Standard-8 cameras (secondhand only).

21. Built-in Macrocapability: All reflex S-8's are capable of macro (closeup) photography through the use of accessory closeup lenses. However, there are some cameras which have built-in lens extensions enabling the film maker to execute extreme closeups with much more ease and efficiency. Built-in macroextensions on zoom lenses can actually enable one to change focus all the way from one-to-one magnification to infinity in one take.

22. Autofading: A mechanism in the camera (or a provided accessory) which provides for an automatic fade-in when the shutter button is activated, or an automatic fade-out when the shutter button is released.

23. Backwinding: A means of winding the film backward so that reexposure over previously exposed footage is possible. A necessity for lap dissolves and superimposition. Only a few Super-8's have this capability to a limited extent. There is, however, a large choice of Single, Double-Super, and Standard-8 cameras with backwinding capabilities.

24. Variable Shutter: The smaller the shutter opening, the faster the shutter speed. This is not to be confused with lens "openings." A variable shutter is handy to have when you are shooting action, in that a faster shutter speed will freeze the action and create a sharper, crisper effect on the screen. Variable shutters are also used to cut exposure, thus requiring a greater f-stop. (See "Exposure," Chapter 6.) They can also be used to make fades if you slowly close the shutter aperture to zero.

25. Electronic Flash Sync: A means of synchronizing electronic flash with single-frame exposures for time-lapse photography.

II

FILM MAKING

The movie maker is bounded on all sides by rules. There are a thousand do's and five thousand don't's, each one of which seems to stand as a roadblock to the ultimate goal: a finished film. However, don't panic.

Basically, the rules have one common denominator. The motion picture is, in part, a dramatic art. Its prime purpose is to draw a response from an audience, which it always does. The response, however, may not necessarily be that which the film maker had in mind when he made the film. Boredom and headache, indeed, are typical responses. The audience may laugh when it is meant to sob, or it may rage with hatred when it is supposed to melt with love. All the rules are calculated to help the film maker elicit the specific response he is seeking. In this lies the art of film making.

Everything the film maker does with the camera must make the collective eye and mind of the audience see and feel exactly what the film maker had in mind.

Chapter 4

FOCUSING

MOST movie-camera lenses require visual focusing. The exceptions are usually inexpensive cameras with fixed-focus lenses. It is important to understand, however, that the total area found in many reflex viewfinders cannot be used for focusing. If one attempts to use the entire field, the image in the viewfinder may continuously accommodate itself and appear sharp, while the lens, relative to the film plane, may be out of focus.*

Reflex viewfinders with focusing capability are provided with focusing aids, usually in the form of microprisms, range finders, or ground-glass inserts. Cameras without these aids are usually not meant to be focused visually. The various types of focusing aids are:

1. Split-Image Range Finder: A circle in the center of the finder which is split in two. Each half presents an offset point of view of the subject. As the focusing ring is turned, the two divergent views come together, at which point the lens is in focus.

2. Coincidence Range Finder: A circle in the center of the viewing screen which presents a double image of the scene. When the subject converges into a single image the lens is focused.

*Exception: the Beaulieu, which has the option of full ground-glass viewing and focusing.

3. Ground-Glass Insert: A circular ground glass occupying the center of the focusing screen. When the image appears sharp to the eye, it will be in focus.

4. Microprism: A circular area in the center of the screen which, in effect, contains hundreds of tiny prisms. When the subject is out of focus, it is broken up into hundreds of divergent images which seem to shimmer as if heatstruck. When this dispersion is cleared up, the subject is in focus.

Focusing through zoom lenses should ideally be done with the lens set at its longest focal length (telephoto position). Since a zoom lens is formulated and constructed to hold focus throughout its entire range, when the lens is focused at its telephoto length it will remain in focus at any subsequent focal length (as long as the distance between the camera and the subject remains constant). When you are focusing at the longer focal length, objects in the viewfinder seem to pop in and out of focus much more readily. It is sometimes difficult to focus with a lens pulled back to its widest or shortest focal length.

To sum up, concentrate your focusing eye on the center area of the reflex finder, whether it be microgrid, ground glass, or range finder. Focus quickly and decisively. Focus with the zoom lens at its maximum telephoto position, then zoom back to the desired focal length and shoot.

Good focusing habits pay off. Focus up to and slightly beyond the point of sharpness, then slowly back again. Learn which way your focusing ring turns. Clockwise toward infinity or counterclockwise. Cameras differ in this respect; learn about yours and practice a bit until focusing becomes almost a reflex action. A few seconds should be all that are necessary to focus at full extension, reset the focal length, and start shooting. You are liable to miss the shot completely if you take too long. Also, if you spend too much time focusing, you're liable to be struck down with a nonfocus syndrome, where everything or nothing

looks sharp. When this happens, remove your eye from the finder, count to ten, and start again. And oh yes, did you remember to set the diopter adjustment on the viewfinder eyepiece? This adapts the viewfinder optics to the peculiarities of your eyesight. You can usually do this by rotating a ring on the finder eyepiece. A few cameras have other ways of accomplishing the same function, so check your camera manual. Point the camera toward a blank wall, or a similarly featureless object, and while adjusting the eyepiece, concentrate your eye on the center ring in the finder until *it* becomes sharp.

As mentioned previously, Bell & Howell produce a line of "Focusmatic" cameras which through the application of an ingenious triangulation method automatically indicate the subject-to-camera distance when the camera is pointed down at the base or the feet of the subject. The distance is then transferred manually to the distance scale on the lens.* This system works well, but what does one do when his subject is footless and overhead? Answer: One uses the depth-of-field focusing method.

Depth of Field

The important thing about depth of field is that it can be used as an extremely effective focusing tool. For outdoor shooting, when the light level calls for relatively small apertures, depth-of-field calculations can easily be used almost exclusively to determine focus settings.

Depth of field, often incorrectly called depth of focus,† is that area both in front of and beyond the point of sharp focus which will still appear adequately sharp. In other words, there will always be an area of acceptable sharpness approximately one-third forward of and two-thirds behind the subject. For example, a depth of field of nine feet sets up an area of adequate sharpness of focus extending from about three feet in front of the subject to

*There are a few Focusmatic cameras that do this automatically.
†Depth of focus is an internal measurement and does not concern us here.

six feet beyond the subject. If the subject moves anywhere within that area, it will remain in focus. Depth of field is determined by the following factors:

1. *Aperture:* The smaller the lens aperture, the greater the depth of field. An f/11 aperture will produce a greater depth than an f/5.6 aperture.

2. *Focal Length:* The shorter the focal length, the greater the depth of field. Wide angle produces greater depth of field than telephoto.

3. *Distance from Subject:* The greater the distance from the camera, the greater the depth of field. A camera focused at 30 feet will have greater field depth than one focused at 10 feet.

4. *Projection Magnification:* At large magnifications with the audience too close to the screen, apparent depth of field is decreased.

In the Appendix, the reader will find four depth-of-field charts. They are printed back to back so that they may be cut out in two groups of two, if the reader desires. It is suggested that they then be laminated. Lamination as a service is offered at some Woolworth's and other variety stores. The resultant cards will be portable and rugged. The charts are simplified for convenience. They include four focal lengths and will prove to be of great value if carried with the camera at all times.

Here are some examples of the way depth of field works to help you focus:

1. Let us say that you have a shot where a group of people are running toward the camera. We are using a 20mm focal length. Let us go on to say that we want to keep the background, a mountain range, in focus. Our aperture reading is f/8. If we set the distance scale on the focusing ring at 15 feet, our running

When you are shooting in the extreme macroranges of relative image sizes of one to one and greater, depth of field is minimal and the slightest camera movement is amplified. Use a tripod and try not to fry your subjects with hot lights (turn them on for short periods only).

group will remain in relative focus up to 6 feet in front of the camera. The mountains, 20 miles away, will also remain sharp.*

2. Same scene, with focal length widened to 9mm, aperture f/8 and focus set at 3 1/2 feet; our running friends will remain reasonably sharp to within 1 1/2 feet of the camera. The mountains in the background will also remain sharply focused.

3. We are still concerned with the same runners. However, this time we want to zoom back as they approach (in some cases this can be an effective shot, as the runners' image size will tend to remain constant). Our zoom will go all the way from 56mm to 9mm (any zoom range will work, however, if it is set up properly). We have to rehearse this one, to make sure that the zoom is smooth and slow enough so that it won't get ahead of our approaching subjects. Starting the run in from about 100 feet, with the focal length set at about 56mm, we want our zoom to reach completion (9mm) when the subjects get to within 5 to 8 feet of the camera. To accomplish this, we will probably have to operate the zoom control by hand.† Because this shot might be more effective in slow motion, our f-stop has now opened to f/5.6.** We set the lens at infinity (∞). At the start of the run, everything from 86 feet to infinity will remain in focus. By the time we have zoomed back to 40mm we will be in focus from 47 feet to infinity. Continuing to zoom back, we reach the 28mm focal length, and a depth of 23 feet to infinity. Our running group should be about 20 feet from the camera when the focal length reaches 15mm, at

*Photographically speaking, 20 miles away is considered as "infinity." Infinity is expressed as ∞, and is so engraved on lens-barrel focusing scales. Infinity is a point beyond which everything will remain in focus. If, for instance, you focus on a distant tree, your lens focusing scale will read ∞ and everything beyond the tree will be in sharp focus regardless of the f-stop being used. If "infinity" falls within the depth-of-field calculations, the same holds true.

†A few manufacturers provide infinitely variable zoom speeds. The Minolta D-10, for example, provides a variable-power zoom control of from 2 to 12 seconds.

**Overcranking (slow motion) increases the shutter speed of a movie camera, thus the light coming through the lens has a shorter time to react on the film. To compensate for this, the diaphragm is opened to a predetermined f-stop. In most S-8 cameras, this is an automatic function.

Depth of field, relative to f-stop.

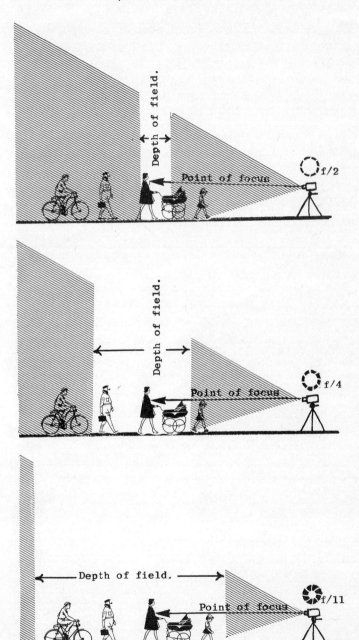

which point we are holding focus from 7 feet to infinity. By the time we reach the 9mm mark, all becomes academic, as we are still sharp all the way from 3 feet to the Rocky Mountains!

One important advantage of using depth of field as a focusing tool is quite evident in this last example, when you consider the alternative, which would entail the simultaneous operation of zooming and focusing controls.

It should be obvious by now that depth of field is the best friend you have in the focusing department. Before you shoot, it pays to check the area of action, and compute it against f-stop and focal length to determine field depth. You will find that in most cases your focusing problems will thus be solved. It is for this reason that cameras which do not have the facility for focusing by the depth-of-field method are not recommended for the serious amateur.

Under some shooting conditions, such as bright sunlight when you are using relatively short focal lengths, depth of field becomes academic. Under these circumstances, focusing anywhere near the subject will usually ensure adequate depth for most purposes. However, if you restrict your movie making to those so-called ideal conditions, you would be better advised to purchase the cheapest fixed-focus camera available.

The Yashica Super-800-Electro (and a few other cameras) provides click stops on the focusing ring at 6 feet, 15 feet, and 30 feet. This is an extremely convenient feature, both in terms of setting depth of field and of presetting focus.

An alternate method of accomplishing relatively the same thing is to glue (with a strong epoxy) three small beads at these three positions on the focusing scale. A fourth bead should be added on the inner lens barrel over the indicator line. Make certain that this fourth bead does not jam the focusing ring when it rotates back toward the infinity mark. The beads thus become a visual reminder of three convenient and efficient footage readings for determining depth of field.* They can also serve as

*As the simplified depth-of-field charts indicate, there is a fourth setting, infinity (∞). However, since the infinity mark is at the limit of focus-ring rotation, click or bead stops are not necessary.

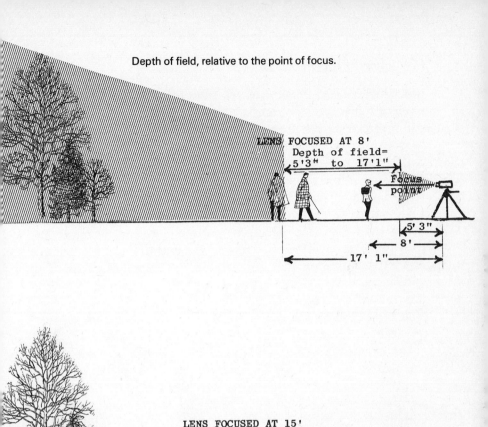

Depth of field, relative to the point of focus.

LENS FOCUSED AT 8'
Depth of field=
5'3" to 17'1"

Focus point

5' 3"
8'
17' 1"

LENS FOCUSED AT 15'
Depth of field= 7' 6" to infinity.

Focus point

7' 6"
15'

Infinity

tactile indicators for follow-focus techniques. It is also possible, after considerable experience, to learn or memorize depth-of-field settings for these four positions. Total precision is not always important.

Follow Focus

There are situations when the subject in motion moves rapidly from a distance of a few feet from the camera to a few dozen feet

or more. Depth of field as a focusing method then becomes impossible. A follow-focus technique is called for. "Follow focus" is purely and simply what the term implies: You focus the lens continuously to keep the subject in the plane of sharpness.

As the subject approaches or recedes from the camera, a constant focusing and adjustment might sometimes be necessary to hold focus, particularly in unrehearsed or documentary situations. This is especially true when you are using long focal lengths or shooting with a relatively wide aperture. Under these circumstances, depth of field is minimal.

There are times when follow focus can be combined with depth-of-field calculation. If, for example, there is action that moves slowly from one plane of focus to another, we can follow focus until we reach a point that ensures adequate depth of field to cover subsequent focal-plane shifting, for example, a football play taking place 10 feet in front of the camera. With the focal length at 40mm and the aperture set at f/4 there is only about a 2-foot depth of field, hardly enough to depend on. Under these circumstances we have no alternative but to focus by eye. We follow focus as the action moves away from us, until the camera focusing ring reaches the 30-foot mark. At this point our depth of field has increased considerably and encompasses an area of about 45 feet (from 24 to 71 feet), possibly enough to hold focus for the rest of the play. If not, we can estimate when the action passes out of this zone to 60 feet and refocus or return to the follow-focus technique. We know when we have reached the 30-foot mark on the focusing ring because we have: (1) made use of the (Yashica-type) focusing-ring click stops on the camera; (2) installed the indicator beads mentioned earlier and can judge the distance scale by feel; or (3) we have held a finger on the 30-foot mark throughout the entire shot and can judge roughly when it comes up opposite the indicator line on the lens barrel.

When you are following focus, it is more important to focus smoothly and decisively than to be on the button, so to speak. Rather than jerking the focus from one point to another, try to

stay with it. A slight front focus is not a disaster, as depth of field will tend to take up some of the slack.

Selective Focus

Selective focus is used primarily to isolate the subject by throwing the foreground and/or the background out of focus. More often it is the background, as out-of-focus foregrounds tend to be unpleasant to the eye. With S-8 cameras, selective focus is often difficult to accomplish because of the relatively short focal lengths involved. However, it is a very effective device, and quite important cinematically.

A confused background that is sharp is much more disconcerting than the same background thrown out of focus. Contrary background elements, when sharp, might tend to draw the eye and attention away from the matter at hand. There is, in addition, a pleasant aesthetic quality to some types of unsharp background. The lines soften, and masses resolve themselves into soft shapes. The colors seem to lose their saturation and take on a pastel quality. This is especially true if the background is somewhat overexposed, as it often is under these circumstances. (See Chapter 6.) In many situations it is enough just to indicate the background or the background action rather than showing it all in unnecessarily sharp detail. By isolating the main subject against a soft background through selective focus, you reinforce its importance. The eye of the audience will be drawn and held to the subject and will have less of a tendency to stray to sharp background detail. A softly focused background can serve as a sketch of the environment within which the action is played.

The prime requirement for selective focus is an extremely narrow depth of field, but with the high emulsion speeds of today's films it is a rare lighting situation that calls for a wide enough aperture. The answer to the problem is the neutral-density filter. Neutral-density filters screw onto the front of the

An example of selective focus resulting in a softly focused background against which the foreground figure gains emphasis.

taking lens and are a neutral gray in color so that they add no coloration to the film. They come in a variety of densities and are quite inexpensive. The Tiffin ND 9 filter is a good compromise. It requires opening the diaphragm three stops. Thus, if the f-stop in use at the time is f/8, the application of an ND 9 neutral-density filter will cause the camera's autometering mechanism to open the diaphragm three stops to f/2.8.* With focal-length settings 30mm and longer and reasonably close focal distances, selective focus becomes a reality. An even better way of accomplishing the same thing is through the use of two polarizing filters screwed together. If you rotate one of them the light passing

*With nonauto diaphragms, exposure changes must be made manually.

through the lens can be varied continuously from minus four stops to total blackout. If four stops are more than are needed, one of the polarizers can be removed, resulting in only a two-stop exposure increase. (See Chapter 10.) Selective focus works best with the lens diaphragm wide open (on a telephoto of 30mm or longer).

Focus Shift

A very effective way to shift emphasis from one plane of action to another is to shift focus during the shot. This is a very dramatic device, and, like zooming, it should be used with restraint. It is quite often used to let the audience in on something that the main subject or subjects are not aware of. For example, in the foreground is a deer with the background completely out of focus. Without a change in the framing, a shift in focus reveals a hunter lying prone in the foliage. The audience is aware of the hunter, but the deer is not. This kind of shot is effective because it sets up two visually disconnected planes of action. A rapid focus shift from one to the other will convey a sense of shock, whereas a slow focus shift will build suspense.

Focus shift as it applies to this example can also be used to tell a different tale: the camera is on the deer as it looks up startled, then a quick focus shift to hunter as he fires. The following shot shows the deer unharmed (hopefully) running into the woods. Here is a situation which is subjective from the deer's point of view. The audience is made aware of the hunter at the same time the deer sees him. The audience's eye is the deer's eye as it focuses on the heretofore unseen hunter.

Focus-shift technique should always be executed with the lens at its widest aperture. (Focal length should never be less than 50mm.) To accomplish this, a neutral-density filter, or two polarizers, can be used.

7mm focal length.

25mm focal length.

Chapter 5

ZOOMING

THE main function of a zoom lens is to provide an infinite number of focal lengths within its ratio. The variable-focal-length lens is a magical device which can perform most of the functions of a host of wide-angle, normal, and telephoto lenses. Its zooming function is a bonus, which when used meaningfully and sparingly can create an important addition to filmic language and punctuation.

Film making, like writing, uses punctuation marks. The most common pitfall is the too frequent use of the exclamation point, the zoom-in. S-8 camera owners, proud of their smoothly operating powered zoom lenses, ranging all the way to 12-to-1 ratios, treat them as toys. It is so satisfying, so effortless to operate that little rocker switch. It can be terribly exciting. Through the viewfinder your camera eye soars out to the horizon on command. You zoom back as if you were riding the tail of a rocket, watching the world widen out below you. On the screen, however, the zoom in either direction must have a specific purpose. The zoom can propel your audience (who are just sitting there minding their own business) through space, and they expect it to pay off in some way.

The zoom is used to emphasize something of importance. It accomplishes this by hurtling the audience forward, till it finds itself confronted by a closeup of the subject which has now become a thing of ultimate importance . . . climactic . . . an

exclamation point at the end of the "sentence." If this is what you've attempted to do, and if the subject makes an important point and is relevant to what you are saying, then you have made a successful zoom shot. If, however, you've zoomed in on a subject not relevant to your filmic statement, then you have misled your audience, and they won't forgive you.

Just as zooming in tends to emphasize the subject, zooming back deemphasizes it. Therefore, to zoom one way and then another is a contradiction and creates total confusion. Zooming back tends to place the subject in perspective. For example, if you slowly zoom back from a closeup of a house, you place it in context with its environment. If the house is incongruous in its environment, say a slum dwelling smack in the middle of a posh urban development, then zooming back becomes a long descriptive sentence, revealing more and more as it progresses. The appetite of the audience for more explanation is being continuously satisfied, until finally we see the house in a wide shot, surrounded by its rich neighbors. We've started with an isolated slum dwelling, and in the course of the zoom-out, we have a complete social statement.

Zooms in either direction should be used sparingly. As a dramatic device, zooming loses its impact when overused. There are exceptions, of course. To emphasize the frenetic quality of, for example, a political demonstration, or a bad traffic jam, the employment of a series of fast zooms (each with a specific target) is an exciting rhythmic device which will involve the audience emotionally. But the zooms must be meaningful; each closeup must be symbolic of the general action. And the quick-paced zooms should all be in one direction.

When you are using a series of rhythmic zooms, one following another, it is usually more effective to cut the shot before the lens zooms to completion. The following shot begins with the lens already well into its next zoom. The effect on the screen is a single continuous inward or outward movement, which carries the audience from one exclamation point to another. As many as ten fast, pulsating zooms can thus be laid end to end, but if

36mm focal length.

56mm focal length.

70mm focal length.

you're going to "zap" your audience with this kind of thing, you'd better make quite sure that the subject matter justifies your efforts. Some examples: riots, demonstrations, certain types of athletic competition (football, ice hockey, etc.), political conventions, traffic jams, etc.

Another more sedate use of the reiterated zoom can be used to provoke an entirely different audience reaction. A series of slow, unresolved zooms connected by lap dissolves (see page 147) can create an almost poetic feeling when used, for example, with flowers, animals, children, pretty girls, sailboats, etc. (this technique will also work, though to a lesser degree, without the softening effect of the lap dissolve). With the proper choice of music in a sound presentation, the effect can be beautiful. This slow, repetitive zoom, if well conceived, is a very useful device for travel documentaries.

Chapter 6

EXPOSURE

PHOTOGRAPHIC film sensitivity is graded by a series of numbers called "ASA ratings." The "slowest," or least light-sensitive film, is Kodachrome II, which is rated for daylight at ASA 25. The "fastest," or most light-sensitive film you are liable to use, is rated at about ASA 800, provided your camera is equipped for it.

All Single-8 and Super-8 cameras are equipped with internal mechanisms which, when keyed by slots cut in the film cartridges, automatically program the appropriate ASA ratings into the autometering systems. As will be pointed out further on, a knowledge of ASA ratings is important in determining the choice of film relative to lighting conditions, depth of field, etc. Double-S-8 requires ASA ratings to be set manually.

A film rated at ASA 100 is twice as sensitive as one rated at ASA 50, which in turn is twice as sensitive as one rated at ASA 25.

Higher ASA ratings call for decreased exposure (smaller apertures). Lower ASA ratings call for increased exposure (larger apertures). The more light sensitive the film, the less exposure needed to create an image, and vice versa.

This ratio works out to one f-stop difference each time the ASA is halved or doubled. For example, if you were shooting an outdoor scene using GAF color film rated at ASA 25, at an exposure of f/8, and for some reason you decided to switch

magazines to Kodak Plus-X, rated at ASA 50, your exposure would automatically be decreased one f-stop to f/11 (see page 195).

Underexposure occurs when the light passing through the lens onto the film is inadequate. This happens when: (1) there is not enough light in the scene; (2) the subject is strongly backlit or is against a very bright background; (3) with Standard-8 or Double-Super-8 autoexposure cameras, the ASA rating has been set incorrectly; (4) a malfunction has occurred in the camera autoexposure system; (5) a neutral density or polarizing filter is being used in inadequate lighting conditions; or (6) the ASA setting on a hand-held meter is incorrect.

Overexposure occurs when there is too much light passing through the lens onto the film. This happens when (1) a fast film is used in bright outdoor lighting conditions, and the camera is incapable of stopping down far enough to compensate;* (2) autoexposure is used for a spotlit theatrical event, or any other bright subject against a black background; (3) an incorrect setting is made of the ASA rating on automated Standard-8 and Double-Super-8 cameras; (4) an incorrect setting is made on a hand-held exposure meter; or (5) a malfunction occurs in the autoexposure system.

With hardly any exceptions, all S-8 cameras are equipped with automated exposure control. This means that when the camera is pointed at a subject, a photoelectric cell "reads" the amount of reflected light, and through the use of a servomotor, or some other device, adjusts the lens opening or diaphragm accordingly. With few exceptions, all but the least expensive S-8 cameras have their photoelectric cells located behind the lens, so they actually read the light entering the lens itself. In most average situations this arrangement works well, particularly since it is aided by the exposure latitude of modern film emulsions (most films today

*Some cameras can handle a good deal of this. The Movieflex GS-8, for example, stops down all the way to a minuscule f/64! This is four stops less than cameras which allow only a minimum exposure of f/16.

will accept underexposure or overexposure of one stop without disastrous results).

Naturally, there has to be a standard toward which auto-exposure directs its efforts. The universally accepted basis for such a standard is an 18-percent gray. It works this way; all the light accepted by a (reflected) light meter or photo cell is integrated and compared to an 18-percent gray tone (a very light gray). This means that the meter will attempt to adjust the aperture to produce the equivalent of an 18-percent overall-gray integrated tone on the film.

To put it more simply, if when using autoexposure we shoot a white card, the resultant picture will be an 18 percent gray, and if we photograph a black card, the autoexposure mechanism will attempt to produce the same shade of gray. It follows, then, that autoexposure systems will always tend to produce the equivalent of an 18 percent gray no matter what the subject.

Fortunately, most *"average"* subjects fall fairly close to this 18 percent ideal. If we take a typical outdoor or indoor scene involving people under average circumstances, reflectance will be close to the 18 percent the meter is based on. The results will more or less match the original. However, what happens when we are shooting a medium shot or a long shot of a skier against bright white snow? The meter will perceive this scene in its usual mindless way, as an integrated, very light shade of gray, rather than as a relatively dark subject against an extremely bright background. Since the background is dominant in terms of light reflectance, the diaphragm will be stopped down accordingly, and our skier will be underexposed considerably, resulting in an almost total silhouette. The same applies in varying degrees to subjects in beach scenes, seascapes, and scenes dominated by a large area of bright sky. Unless the subject fills more than half the frame in these examples, underexposure will result. It must also be pointed out that snow-covered hills, bright seascapes, etc., when photographed as pure scenics (where proper exposure on an isolated subject is not important), usually respond dramatically to automated exposure readings.

An uncompensated exposure against brilliant sand, sea, and sky, resulting in underexposure of the two subjects and creating a dramatic silhouette.

When you are photographing a theatrical performance lit by a spotlight, the through-the-lens meter is just about useless. The meter will respond to the dominant black area surrounding the spotlit figure. The smaller the frame area filled by the performer, the greater the overexposure. This applies to any light object against a black or dark background.

All, however, is not lost. As noted earlier, all quality S-8 cameras have some means of overriding or adjusting the "decisions" of their built-in automated meters.* This is accomplished in one of three ways:

1. Manual Override: A means whereby the automated function of the built-in meter is switched off and the aperture is set manually.

*There are some inexpensive S-8 cameras with no override system. These are limited in their versatility in that exposure adjustments cannot be made to their automated exposure controls to take care of the problems discussed here.

2. Over-and-Under Compensation: A means whereby the indicated exposure reading in the finder can be increased or decreased by one or more stops.

3. Exposure Lock: A control that locks the diaphragm at a predetermined f-stop, generally through the use of closeup readings. A somewhat awkward expedient, but workable.

When you are using a camera that provides manual override, the most professional way of determining exposure is through the use of a separate hand-held exposure meter. The best type of exposure meter for this purpose is the incident type. This type of meter, rather than reading *reflected* light from the scene, reads the actual light *falling* on the subject. You take a reading by placing the meter at the subject position and pointing its light receptor toward the camera. This works very well for things like backlit beach scenes, etc., but what to do if your subject is beyond reach? For example, a speeding skier, or a swimmer, or a backlit subject two blocks away as seen through a telephoto. The solution is to place the incident-light meter in exactly the same kind and amount of light as that falling on the subject. It doesn't matter if the subject is ten feet or ten miles away, as long as the incident meter is on the proper subject-camera axis and is lit in the exact same way as the subject. When the meter is then pointed at the camera, a true reading will result. If the subject is under sky light, make sure that the meter is also under sky light. If the subject is shaded by a tree, cast the same type of shadow on the meter, either with another tree or with your hand.

The incident-light meter is unaffected by the amount of light being reflected back from the subject. Its only concern is how much light is falling *on* the subject. In identical lighting situations, it will read out the same f-stop for a snow scene as it will for a black wall. Therefore, unlike the reflected-light meter (the type built into S-8 cameras), the incident-light meter will give the result of *white* snow or a *black* wall on the final film.

When using an incident-light meter in conjunction with a

camera which provides an autoexposure override, place the camera's autoexposure control on "manual," and use the incident meter's indicated f-stop instead. Controls are provided on the camera to accomplish this, and the f-stop readout in the finder is used as an indicator.

In a somewhat limited way, cameras providing over-under compensation can also be used with an incident-light meter. There will seldom be more than a two-stop difference between readings obtained from built-in autolight meters and separate incident meters. Therefore, a camera equipped with an over-under autoexposure compensating system is compatible, to a large degree, with the use of a hand-held incident-light meter. A reading is taken with the incident meter, and the f-stop indicated in the camera finder is adjusted by the use of the camera's over-under control until it is in agreement with the incident meter reading.

Using a separate incident meter with cameras equipped with exposure locks is also possible. A reading is taken with the incident meter, and the resultant f-stop is locked into the camera's autoexposure system through the use of a switch. You can accomplish this by controlling the light entering the lens until the f-stop readout in the finder is equal to that obtained from the incident meter. At that point the exposure control should be locked, and the indicated aperture will hold until it is unlocked.

To obtain a wider aperture, turn the exposure-lock camera gradually toward a bright light until the desired f-stop is indicated in the finder. To obtain a smaller aperture slowly pass a hand in front of the lens until the desired f-stop is indicated.

Selected closeup readings can also be taken with cameras equipped with exposure locks. It is simply a matter of approaching the subject, until it fills most of the camera finder. At that point lock in the acquired f-stop. When the camera is pulled or zoomed back, the locked f-stop will remain in effect. This technique is effective for backlit subjects and for subjects which contrast sharply with their backgrounds.

Closeup readings are possible with autoexposure override systems and with over-under compensation also.

When using cameras equipped with override, take a closeup reading with the subject filling more than one-half the finder area. Then use the resultant f-stop reading in the finder for the final exposure, with the meter switch on "manual."

Contrasty lighting is the bane of all types of exposure meters, reflected and incident alike. This is particularly true for color film. In situations where a strong side light is present, for example, it usually pays to take a closeup reading of the highlight area and to use that reading as the basis for exposure. If the highlight reading is within two stops greater than the overall reading or falls within that range, the difference should be split. For example, if the reading in an overall full-frame lighting situation indicates that the exposure is f/2.8 and the separate highlight reading (taken from the brightly lit side of your subject's face, for instance) is f/5.6, you'll find that there is a two-stop difference in exposure.* Splitting the difference, you arrive at a shooting exposure of f/4. This exposure will keep the highlights from washing out completely and will still retain some detail in the shadow area. When the difference is greater than two f-stops, always expose for the highlights. In other words, when you are using color film, if the overall light reads out at f/2.8, and the highlights at f/8, then f/8 is your shooting exposure—no *if's, and's* or *but's.*

With black-and-white film, however, there is far more latitude. A two-stop difference can be ignored. When the ratio exceeds two stops, it then becomes important to split the difference.

However, if you are after a dramatic low-key effect in contrast lighting situations, then you should expose for the highlight areas, regardless of the ratio involved.

*Rather than using the generally accepted highlight-shadow ratio, because of the idiosyncrasies of the autoexposure systems in the S-8 cameras, we are dealing with a ratio resultant from comparing highlights to general *overall* lighting in the scene.

When using an incident-light meter in a highly contrasty lighting situation, such as occurs with side lighting, direct the meter toward a point halfway between the camera and the main light source.

When shooting color, it is always safer to err on the side of underexposure rather than overexposure. When in doubt, reduce the aperture by one-half stop to be safe—it can't hurt. Washed-out, featureless highlights, caused by overexposure, are far more disconcerting than the blocked-up, dark, opaque shadows caused by underexposure.

There are times when dim light is a severely limiting factor in certain types of documentary shooting. Built-in autoexposure meters, marvelous devices though they may be, are incapable of reading extremely low light levels. It may seem odd, but there are S-8 films available which are more sensitive than most built-in meters. Even though your camera may not be programmed to adjust its metering system for ASA film-speed ratings of, say, 400 or 500 or even more, such films exist, and they can be used in many S-8's for dim-light photography. All that is required is an external light meter, preferably of the CDS incident type. It then becomes a simple matter of setting the super speed ASA rating into the separate meter, taking the reading, and adjusting your camera to the resultant f-stop by one of the three previously mentioned methods. Situations that require an exposure increase of as much as four f-stops, or 16x over the maximum autoexposure reading, can be rescued using this method (on exposure lock and manual override cameras).

Chapter 7

FILM STOCK

AT this time, all available S-8 film is of the reversal type, which when developed produces only a positive image (there is no negative). There are, however, great differences in the various brands and kinds of film available both in color and in black-and-white. These differences are determined by various physical and chemical characteristics and their relation to grain, speed, color saturation, maximum density, acutance, and contrast.

1. *Grain:* Particles that together form the image on the film. When grain is visible at normal viewing distance from the screen, the film is generally considered grainy. Graininess is present both in color and in black-and-white emulsions (i.e. film stock).

2. *Speed:* The degree of sensitivity to light of any given film brand or type. As mentioned previously, film speed is measured by a series of "ASA" numbers. The higher the number, the more sensitive or faster the film. The lower the number, the less sensitive or slower the film. Black-and-white emulsions are usually faster than color emulsions.

3. *Color Saturation:* The degree of color intensity inherent in the film. Some color films tend toward a brilliant, flamboyant quality, others toward a pastel, subdued quality.

The "Greatest Show on Earth" is great fun to shoot. For the best vantage points, try to get seats in the loges facing the *front track*. This is the side of the auditorium to which the circus traditionally plays. A basic exposure of f/2 on Kodachrome (ASA 25) or f/4 on 125-160 ASA film is recommended. Activate the daylight filter for situations in which the arc lights predominate.

4. *Maximum Density* (*D. Max.*): The degree of density in unexposed areas of the film. The opacity or blackness of black areas of the processed film is quite important in terms of image quality. A low maximum density indicates that the film has been processed incorrectly, or that it is old (dated), or that it has been stored improperly, or that it has been fogged by light or chemicals, or that it has been improperly reversed during processing, or that there has been a temporary malfunction in the manufacturing process, or that it is just plain lousy film. Any of the above can be responsible for low D. Max. A quick eyeball check can determine roughly the degree of D. Max. If the dark areas of the film, when projected, seem to lack density, if it seems as if you can "see through" the shadow areas, or if they have a green or brown cast, the D. Max. is decidedly low. The film has

been robbed of saturation and contrast. If this problem occurs frequently, write the manufacturer.

5. *Acutance and Sharpness:* Acutance relates to edge sharpness, or the ability of a film to define a dividing line between two tones. Sharpness relates to the degree of internal definition. To date, Kodachrome II is the sharpest color film available, and it always has been.

6. *Contrast:* The degree to which any film differentiates between light and dark tones. A film, either color or black-and-white, that is deficient in reproducing the difference between middle tones of a gray scale going from white to black is thought of as a high-contrast film. A film that seems to be lacking in blacks and whites and consists mostly of middle tones is considered to be of low contrast. Both of these phenomena can be simulated on a TV set (color or black-and-white) if you manipulate the contrast control.

In terms of film choice, everything has to be paid for in one way or another. For example, if you want to use a highly saturated, relatively grainless color film with good contrast, you have to pay for it with lack of speed. Such films are Fugichrome AT-25 Daylight (ASA 25), Fugichrome AT-50 Tungsten (ASA 50), Eastman Kodachrome II Type A (Tungsten ASA 40, Daylight ASA 25), and Agfachrome CK 17 (Tungsten ASA 40, Daylight ASA 25).

On the other hand, if speed is what you're looking for, you have to pay for it with reduced contrast, reduced color saturation, and increased grain. The color films which manage to make these compromises gracefully are Eastman Ektachrome EF (Tungsten ASA 125, Daylight ASA 80) and Eastman High Speed Ektachrome 160 (Tungsten ASA 160).

Black-and-white emulsions as a rule are faster than color. Nevertheless, the same rules of diminishing quality still apply. Kodak Plus X (ASA 50) and Fujipan R-50 (ASA 50) are two very

high-quality black-and-white films with excellent contrast, acutance, and grain characteristics. As with color, if you are looking for a faster film, it has to be paid for with increased grain and decreased sharpness. Two films by the same manufacturers as above, Fujipan R-200 and Eastman TRI-X (both ASA 200), pay this price without going overboard. GAF 500 ASA pays a somewhat higher penalty in graininess for its superspeed.

There are even faster S-8 films available, some as fast as ASA 800, and even ASA 1000. These superspeed emulsions extract a high cost in grain and acutance. They should be used only in extremely dim-light situations when all else fails.

Kodachrome II sets the standard to which all others are compared. It has the highest acutance and sharpness of any color film available. Because of processing procedures, it is highly standardized and seldom varies in quality. It is highly resistant to color shifts due to bad storage, heat, and age. Yet, in one respect, this miracle color film is just plain lousy! . . . *Kodachrome II doesn't lend itself to reproduction.** Duplicates or prints made from this film are just too contrasty to be satisfactory. This is an unfortunate paradox, because Kodachrome II projected in the original is superb. However, if prints or duplicates are contemplated, it is recommended that you shoot the original on Ektachrome EF, despite its somewhat grainy and unsharp shortcomings. Prints from this film are quite good, and because of the original low contrast inherent in Ektachrome EF, the inevitable increase in contrast in the printing process doesn't affect the final results significantly. There are other films which also lend themselves well to reproduction. However, I suggest that the reader make his own experiments, as there are new brands and types of film on the market constantly.

Personal taste plays a large part in film choice. As mentioned previously, there are highly color-saturated films that result in brilliant, sometimes exaggerated color. There are films with relatively low saturation which are capable of producing soft,

*Keep posted; this may change for the better.

lovely pastel shades. There are high-contrast and low-contrast films and films with coarse grain patterns. There are films which reproduce colors differently—no two brands treat reds and yellows alike. There are films which respond with brilliant greens when you are shooting foliage and films which accentuate the blue in skylit shadow areas. All these differences can play a dramatic or aesthetic role in the final product. Therefore, since taste plays such a heavy part, personal experimentation is the only means of acquiring the data necessary to make these choices. One note of warning: intercutting two or more different types of film in the same sequence is not recommended. It can be quite disconcerting to an audience to see the heroine's complexion change.

There are two basic types of color film available, "daylight" and "tungsten." Daylight color film has an emulsion that is balanced for the relatively blue light of daylight, while tungsten film is balanced for the orange-reddish color of incandescent light. The human eye adjusts somewhat for these extremes in what is known as "color temperature," but such automatic corrections are beyond the ability of color film. Therefore, the photographer is obliged to use a color film that is balanced for the color temperature of the prevailing light, or to use a color-conversion filter to modify the color of the light before it passes through the lens. An overall blue cast is the result of using unfiltered tungsten film in daylight. An unpleasant heavy orange cast is the result of using daylight film under tungsten lights. Black-and-white films are unaffected by normal color temperature differences. All Super-8 cameras have built-in, automatically programmed conversion filters, enabling the film maker to use just one type of color film indoors and outdoors. This being the case, only tungsten-type (indoor) color film is currently manufactured for use in the Super-8 cartridge. The conversion filter is normally in shooting position in the camera. There are three ways of displacing it:

1. The use of black-and-white film. The black-and-white cartridge is built in such a way that it automatically depresses a

lever in the camera that removes the conversion filter from the film plane. Black-and-white film, of course, does not require the use of a conversion filter.

2. The use of a light bar or camera light mounted on the camera. When such a light bar or camera light is mounted on the Super-8 camera, a metal pin or probe descends into an opening in the camera body and moves the conversion filter out of the way. This converts the color film back to its original tungsten light balance.

3. The use of a manual key, lever, or pin. Most Super-8 cameras are supplied with a pin or a key which fits into a slot or a hole in the camera. This pin or key displaces the conversion filter and the film is thus rebalanced to tungsten light. A few cameras make use of a manually operated lever to accomplish the same task.

Because Single-8, Double-Super-8, and Standard-8 cameras do not come equipped with built-in conversion filters, both tungsten and daylight color films are available for them. However, it is possible, and often desirable, to use converted tungsten film in daylight, and for this purpose auxiliary conversion filters are available which screw into the front lens element (see page 202). The auxiliary conversion filter is a great convenience with these cameras when indoor and outdoor scenes are to be shot on the same cartridge or roll of film. Without the filter one faces the hassle of changing film cartridges or rolls before they are used up. It is much simpler to screw on a conversion filter outdoors and remove it indoors, or when one is shooting under incandescent lights. Tungsten film responds to use with a conversion filter beautifully. There is a light loss of only slightly more than one-half an f-stop due to filter factor, and built-in meters will respond with the required corrected exposures.

A word of caution: Though there are conversion filters available to adapt daylight film for use under tungsten lights, this procedure is not recommended. The light loss due to the high filter factor is considerable, particularly when you consider that light is at a premium in incandescent lighting situations.

Chapter 8

DAYLIGHT

AS mentioned in the previous chapter, all color films are balanced for either daylight or incandescent (tungsten) light. The redness of incandescent light or the blueness of daylight is measured in degrees of Kelvin temperature. The bluer the light the higher the rating. Thus, daylight film is manufactured and rated for light of about 6,000° Kelvin, which is the color temperature encountered under sunny, blue-sky, midday conditions. Tungsten films are balanced for a color temperature of 3,200° or 3,400° Kelvin, which is the color temperature of incandescent light bulbs and lighting equipment especially made for color photography. Black-and-white films, for all practical purposes, remain unaffected by normal changes in color temperature.

Daylight color temperature varies somewhat according to the time of day, but generally stays within tolerable limits until about an hour and a half before sunset, and an hour or so after dawn. Dawn and sunset light are noticeably red. The closer the sun to the horizon, the redder the light. Paradoxically, the light is bluish during the few minutes of daylight that exist after the sun has actually descended beyond the horizon at sunset, or before it has risen above the horizon at dawn. Color filters can make the needed corrections for these variations in daylight Kelvin temperature; moreover the eye can accept red sunset or blue predawn light on the screen, as indicative of the time of day,

provided there are additional clues. For example, when shooting in the reddish light of a sunset, you can intercut the actual sunset along with your somewhat reddish-colored subjects. If, on the other hand, the action or continuity of your film indicates that it is early in the morning, then the bluish light of predawn will be accepted for what it is.

Sky light, as opposed to sunlight, is not nearly as red. Therefore, shooting *into* the sunset or the sunrise, with your subject backlit by red sky and front-lit by blue sky, can be quite pleasing.

Sky light, that portion of daylight that emanates from the open sky, is partially composed of ultraviolet (UV) light, which, though invisible to the human eye, is quite visible to photographic film. In fact, it is as much a part of the photographic spectrum as are red, blue, and green. Color film registers this invisible light as blue. Under conditions in which the sun's light is the main source of illumination (on near subjects), the UV emanations are minimal and may be disregarded. Under sky light, however, where the sun's rays are not falling directly on the subject, UV wavelengths tend to be more prominent (relative to the total spectrum). The problem is most critical in open shade—under trees, in shaded areas created by buildings, etc.

Ultraviolet haze, which develops photographically in long shots, can also leave its stamp of unwanted blue cast on otherwise lovely landscapes and impressive aerial photographs. There are three types of filter which are recommended to combat this problem. They are the haze filter, the UV filter, and the sky-light filter. Chapter 10, "Filters," deals in detail with their uses. Suffice it to say at this point that all three types work well in combating the "blues."

Sunlight, because it emanates from such a powerful source, is naturally responsible for the extremely contrasty lighting conditions of sunlit daytime photography. An obvious statement, and yet, if you look at lunar surface photographs, it is immediately evident that sunlight on the moon is even more

contrasty than on our home planet. The fact that the moon has no atmosphere explains that phenomenon. The Earth's atmosphere scatters and diffuses sunlight into sky light. Sky light modifies the strong shadows created by the sun. This soft, diffused light from the open sky tends to "fill" shadow areas.

The term "brightness range" defines a film's ability to record the darkest and lightest tones in a scene. When the brightness range of a given film is inadequate, portions of the scene which are too bright will record as white, and portions which are too dark will record as black. These white and black areas will be featureless and devoid of detail. Actually what often happens when the brightness range of a given film is exceeded by the contrast of the subject is overexposure and underexposure simultaneously on the same film. Optimally, color film has a brightness range of about three stops. In other words, at best it will tolerate about one stop of overexposure before losing all detail in light areas and highlights, and two stops underexposure before losing all detail in dark areas and shadows. Black-and-white film usually can tolerate a lighting ratio equal to four or five stops. Under ideal conditions, sky-light fill is enough to bring sunlit subjects into a brightness range satisfactory for black-and-white films. On the other hand, the subject-brightness range of color film, though aided considerably by sky-light fill, is sometimes not quite extended enough to deal with such high contrast.

Fortunately, the built-in autometers of S-8 cameras have been calibrated with sunlit front lighting in mind. They will generally provide an exposure that will ensure highlight detail under average daytime circumstances. However, in these sunlit scenes, shadow detail will tend to be lost, particularly on color film.

There are ways to provide additional fill-in lighting in order to cut down the severe brightness range of sunlight. Portable battery-powered quartz lights or sun guns are manufactured which serve well in providing enough light to fill shadows on closeup and even medium-shot subjects, when equipped with daylight-blue dichroic filters, which are supplied as accessories.

Reflectors are also available, or can be easily constructed, which serve the same purpose by reflecting light back onto the subject. Long shots do not require fill-in light to anywhere near the same extent. The nearer the subject, the greater the need for fill light. However, if you fill in shadows in the closeup, you are going to have to match the subject lighting in the medium shot with the same degree of fill. The solutions are to use a low-contrast color film, such as Ektachrome EF, which stands a better chance of providing shadow detail, or, damn the torpedoes, let the shadow areas go. Just make sure you are not concealing anything in the shadows that may be important to your continuity.*

The worst time to shoot is midday, with the naked sun directly overhead. Ugly shadows are cast on the faces, and sometimes even the most efficient use of portable fill lights or reflectors is not satisfactory. The best way around this is to shoot your subjects in shaded areas or to stick to long shots where ugly shadows are not as obvious, or to go to lunch for a few hours. Scenes which do not involve people are of course exempt from this problem.

When shooting documentaries under these conditions, where you have no control over the subjects, a high camera angle is recommended. As for the old cliché of placing the sun over your shoulder when shooting—be careful. In this position, your subjects are facing directly into the sun and unless your script calls for the cast to be wearing heavy sunglasses, you're liable to be in for some squinting. The lower the sun, the greater the squint factor. If at all possible, try getting the sun angled somewhat off the camera axis. Around 20° to 30° is okay and makes for nice modeling without running into the squint area. The old sun-over-the-shoulder cliché is also baloney when applied to scenics and what-have-you. Below 45° it is a flat light with very little character. Avoid it when possible.

Do, however, choose nice overcast days, particularly when

*In many instances, additional fill is provided by reflection from light-colored surroundings, including the ground itself. This is often sufficient to soften shadows considerably.

Backlighting.

shooting people. A light overcast is best. Shadows are just barely discernible, and the brightness range is rarely greater than one stop. The camera can be pointed in any direction without concern and there is just enough subject modeling to keep things interesting. Colors in this type of light have a tendency to be more intense or saturated because of the lack of glare and surface reflection usually caused by naked sunlight.

Backlighting on sunny days is another good type of lighting. When backlit by the sun, the subject is actually being front-lit by sky light, plus sunlight reflected off nearby buildings, portable reflectors, etc. The danger here is the tendency of the sun to shine directly into the lens. This can cause a phenomenon called "flare," which sometimes registers as round' or octagonal spectral patterns on the film. A lens shade or hood helps keep the

sun out of the lens, but when the sun is low in the sky, an additional safeguard is required. A piece of dark cardboard about a foot square can be used to shade the lens. It requires a light stand, or an assistant to hold it, and should actually cast its shadow over the lens itself. Make sure it is not visible in the camera finder. The dramatic beauty of backlighting is worth the extra effort. (See chart, page 204.)

Chapter 9

INCANDESCENT LIGHTING

CLASSIC movie lighting makes much of such devices as "key lights," "fill lights," "backlights," "scrims," "cookies," etc. We will deal with some of this further on, but primarily it all boils down to making something look natural through the use of a considerable amount of "unnatural" equipment.

However, when you are shooting indoors with adequate, well-directed light available, all you need is your camera, a separate exposure meter, and film that is "fast" enough to handle the situation. You will probably be rewarded with "authentic," "realistic-looking" footage.

Available Light

"Available light" photography is obviously the sole solution at events such as the circus, indoor sporting events, political conventions, etc. The only exposure control permitted you at such events is your choice of film. But the rest is easy. There is generally sufficient light and it is well placed. However, even with fast film in your camera, things can get tough if you suddenly find yourself backstage, or in one of those smoke-filled rooms, or at a party, or for that matter, anywhere at all where the light is limited and the activity is frantic. You've got to think on your feet, fast. A moment wasted might cost you the key shot.

Well-lit night scenes are possible with fast color film (see exposure chart, page 204).

First, if possible, take a quick walk around the shooting area with your incident-light meter (the autometer in your camera is worthless in this situation). Though the indicator needle may jump around as if it were suffering from Saint Vitus' dance, forget it. You're looking for averages. Ideally, you should establish an average low and an average high reading. While you are shooting, two separate f-stops are all you're going to be able to handle. Film exposure-latitude can probably be depended upon to take up the slack. As you walk around, establish quickly which areas are bright-light areas, and which are low-light areas. Remember them. Associate them with the two average exposures you've established. Now you're in business. If the area is crowded, find yourself a perch or a base. It should be over the heads of the crowd, and should take advantage, if possible, of the prevailing light direction. In this case, you don't want to shoot into too much backlight. Don't get too high up, or you'll lose all sense of intimacy in your final footage. Stand on a chair in the corner, or on a table or box, or even on that strong camera equipment case you brought with you. Actually establish a stake-out from which you can photograph most of the action. After a time you can change your position. Keep an eye out for other stake-outs—maybe you'll have to carry your perch with you. No heads will get in your way with your eye and camera a foot or two above the crowd. From your perch you can reach out with your telephoto or pull back for unobstructed wide shots. You've predetermined your exposures. The far corner is f/1.8, that area between the couch and the far wall is f/2.8, the doorway is f/1.8, but will read nicely at f/2.8 (particularly if you want to emphasize the drama of the backlight coming through it) the other corner is f/1.8. If you're lucky enough to have a camera with an exposure readout in the finder, you can make your changes visually. If not, count the clicks, keep the camera to your eye, be selective, think on your feet. This is the essence and the excitement of available-light photography.

Occasionally, there are a few things you can do to improve lighting conditions. Move lamps around, remove lamp shades, or

switch light bulbs, placing the brightest ones in the most advantageous fixtures. If you have the room and the foresight, you can cheat a little and bring a few 250- or 300-watt light bulbs with you. They can be used to replace their weaker cousins residing in strategic sockets.

Color film in situations such as these might be out of the question.* A super-fast black-and-white film might be required. It will probably result in harsh, grainy footage, but, in many cases, that will actually add to the ambience—the look and feel of this kind of subject matter.

Using the light that is available at the scene when you are shooting documentary footage may at times be the only alternative. There are locations at which it is often impractical or even illegal to use lighting equipment. Or it may be that there is not sufficient electrical power, not sufficient maneuvering room, or simply that the clutter of alien equipment and the brilliant lights might prove highly distracting to those present. Under these circumstances, consider yourself lucky if there is sufficient available light to shoot by.

"Available-light photographers" sometimes carry a modicum of lighting equipment, the function of which is not necessarily to light with, but to boost what is available to a point where it is photographically usable.

Check to see that the light that *is* available is going where you want it to go. If it is spotty, you're in trouble. If it is spotty because it is coming from overhead, out of those round, recessed spots so favored by modern interior designers, for example, you're in even more trouble. Faces in this kind of light are cast in heavy shadow and the lower the ceiling, the worse the shadow.

Auxiliary lighting for these situations is just that, "auxiliary." This is very important in terms of the philosophy of available-light photography. You are not *adding* light to a scene of this kind, you are *correcting* the available light that already exists. In this case, you want to make use of those terrible overhead spots. Therefore, think of them as useful toplights; don't flood so much auxiliary light on the scene that their effect will be washed

*See the section on the Kodak XL cameras, page 42.

out, as they lend a feeling of reality to your footage. Two floods aimed from the corners of the room should be adequate.

Roughly, your auxiliary lights should be within one stop over or under the intensity of the overhead available toplights. If your auxiliary light matches the available light in the center of the room (provided the room is of reasonable size), you're all right.

This is simple to ascertain quickly. Take an incident-light reading under one of the overhead spots in the center of the shooting area by pointing the meter upward directly toward the ceiling light. Take a second reading by pointing the meter directly at the auxiliary light. If the two light sources are within about one stop of each other, your ratio is about right. If not, and if your auxiliary light is of lower intensity, increase it, move it closer, or add another. If it is brighter, cut the intensity by using one or more diffusers or, better yet, try "bouncing" it off a wall.

The two light readings are not to obtain the shooting exposure, but simply to establish a rough lighting ratio. At one point, forward of the center of the shooting area, if all is correct, the auxiliary light will read about 1 1/2 stops more than the available overhead lights, and at a point somewhere beyond the center, the auxiliary lights will read about 1 1/2 stops less than the overhead lights. These boundaries roughly define your shooting area. Subjects outside this area will be under- or over-exposed. Now, an incident-light-meter reading taken under one of the center overhead lights, with the meter pointed at the camera and about 45° downward, will give you a good average shooting exposure. Auxiliary lights should be placed about two feet above eye level and parallel with the floor. The above method can be used in any situation in which the available light *intensity* is adequate, but the light *placement* is inefficient.

Fluorescent Light

Another type of available light found in many interiors where documentary footage is liable to be shot is fluorescent light. Fluorescent tubes give off a soft, all-encompassing light that does its damnedest not to create modeling or shadows. It is flat and

uninteresting. However, if it's there, it's there, and if you play your cards right, it will work for you.

As with other lighting problems we've discussed, if you establish somewhere in your film just what your light source is, its effect will prove less disconcerting to your audience. You do this, of course, by including the light source in the scene from time to time.

Fluorescent light consists of a spectrum that is discontinuous. Almost every other light source you will encounter emits light consisting of all the colors in the spectrum, and though most "white" light may be dominated by one color or another, it is really a homogenized rainbow. Not so with fluorescent light, which is almost totally lacking in red. For this reason, objects under fluorescent light tend to appear a kind of ugly blue-green on color film. Reds are degraded to a great extent and tend to register as gray. The best way to deal with fluorescent light when you are shooting in color is to use tungsten film (or in the case of Super-8, deactivate the conversion filter) and either #50 red filter, or, better yet, a filter especially made for this situation, such as a Tiffen FLB. (See Chapter 10, "Filters.") The result will certainly not be perfect, but the best that can currently be hoped for. Another alternative is to forget the filter and "bounce" some incandescent light on the scene.

In either case, Kodachrome II and other ASA 25 (40) emulsions will generally be too slow for this type of light. A film of at least ASA 125 is needed.

On occasion, you might come across "daylight blue" fluorescent tubes. These are to be avoided for color shooting if at all possible. However, if you are stuck in such a situation, use daylight film (activate the conversion filter in Super-8 cameras), and use a Tiffen FLD or an equivalent filter. There is also the problem that sometimes occurs when you are overcranking (slow motion) in fluorescent light. A light-pulsing effect might occur on the film. Keep this in mind when shooting at speeds above 24 frames per second.

Another way to defeat the color bugaboos of fluorescent light

Fluorescent light on ASA 125 Ektachrome EF shot through an FLB filter at f/1.4.

is to disregard it completely and light the scene as if there weren't any fluorescent light there at all. Your setup lights, if they are powerful enough, should dominate the fluorescent lights completely. Or, shoot in black-and-white and you'll have no color problems at all.

Bounce Light

Bounce light is an invention claimed by still photographers. Whether or not their claim is justified, bounce light is an ingenious way of solving innumerable problems. It can be used as a main or a key light, a fill light, or an overall flat lighting source. In fact, occasionally, when you are dealing with relatively simple situations, one light judiciously bounced can serve all three of the above functions simultaneously.

When bouncing a light off a wall or a ceiling, you can expect a loss of intensity. The surface against which the light is being bounced will absorb a portion of it, and the remainder of the

light loss will be due to dispersion. However, a few bounce lights can serve the same needs as a battery of direct lights.

Bounce lighting is accomplished by your pointing lights at the walls or the ceiling. In a pinch, when shooting indoor documentaries, you can even use a camera-mounted light pointed upward, in bounce position. Because of the resultant dispersion, bounce light provides its own fill.

In an interior where there are well-placed lighting fixtures, the conventional bulbs can be removed from their sockets and replaced with high-wattage (300 to 500 watts) light bulbs. One or

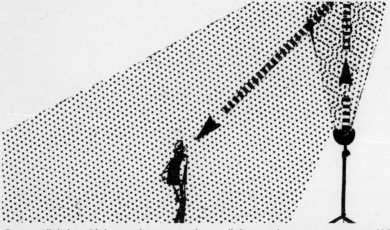

Bounce lighting. Light can be mounted on a light stand or atop a camera. Where ceilings are low or light is close to the subject, point the light slightly rearward.

two well-placed ceiling bounce lights can then be used to supply general overall brightness and fill. This is probably the easiest and most expedient way to light a scene, and if done properly, it can be the equal of far more complex lighting methods.

A *blue* wall will reflect *blue* light; therefore, make sure that the walls and ceilings you are bouncing against are white. Actually, a pure white is hard to come by, as professional house painters have a tendency to mix a little colored pigment into their white paint. To compound the error, white paint also has a tendency to age toward yellow. Therefore, your bounce light is going to be

An example of the soft, almost shadowless quality available from a few bounce lights.

slightly on the "warm" side, a yellow or orange-red. This is not as bad as it sounds, as the slight warming of flesh tones that results can be quite pleasant.

If your lights are rated at 3,400° K and you are using Ektachrome EF film, the relative blueness of the light source should be adequate to compensate for the moderate color shift encountered when bouncing off most "white" walls.

If and when you come up against chartreuse walls and fuchsia ceilings, don't despair. You can make your own white walls and ceilings. All you need do is hang a white sheet against the wall. For ceilings, white cardboard or aluminum foil works fine, with the dull side of the foil facing the light. When taping up your substitute "walls," beware of tape that might peel the paint or plaster.

When bouncing, the closer the light to the reflecting surface, the more direct will be the resultant lighting. Conversely, the farther the light from the reflecting surface, the softer and more

Bounce light.

diffused the resultant lighting. Brightness can also be controlled in this manner. However, a minimum of at least two feet between light source and reflecting surface is necessary to keep from burning the house down.

Corners, where walls and ceilings meet, are very efficient reflectors for bounce lighting. They have a tendency to bounce light into a room in a somewhat tighter pattern than can be obtained from a flat wall surface.

Unless you are attempting to fill an area near the floor, your wall bounce-light source should be set well above eye level. Care should always be taken that direct spill from the light source does not fall on the scene, as this would defeat the entire purpose of bounce light.

Umbrella Light

Still another technique we have to thank still photographers for is the use of white or silver umbrellas for bounce lighting. Umbrellas ranging in size from about 18 inches to about 36 inches are available, with the necessary fittings, from the lighting departments of large camera shops. When mounted on a light stand, they serve as portable bounce surfaces and can be raised, lowered, or tilted. A light is mounted directly onto the umbrella shaft or light stand and directed toward the center of the umbrella. The resultant light is similar to that obtained from wall bounce, except that it can be directed where you want it. Another difference is that umbrella light has the tendency to be somewhat less diffused than wall bounce. This can be an advantage in that more light will fall on the subject. The use of a silvered umbrella, rather than a white one, results in even less diffusion. However, in any case, more than enough diffusion is created to achieve the basic reason of bounce light: *soft lighting.*

Any number of umbrellas can be used in combination with wall and ceiling bounce. They can even be used as overall fill for direct key-lighting.

Umbrella light.
(*Gerald Nieberg*)

Conventional Movie-Lighting

All conventional movie-lighting is built around the triumvirate of key light, fill light, and backlight. The combinations can get a bit complicated at times, with as many as one hundred or more seperate lights being used on major film sets, but the basic formula usually is present.

The primary lighting tool is the key light. The key light determines the light direction and the subject modeling. Except in special circumstances, it is usually placed on one side of the camera, and within a 40° angle from the subject. It can be a flood or a spot, but in either case it determines the exposure. To keep wall and floor shadows at a minimum, the key should be as high as possible. (But watch out for eye-socket shadows.)

A fill light is usually placed on the other side of the camera. Its function is to provide fill-in light for the key. The lighting ratio should be normally about two to one. A backlight is usually placed behind the subject, high and out of the frame, in order to separate him from the background and create a rim-lighting effect. Additional lights, usually floods, can be used to light the

Conventional movie lighting using key and fill lights.

background, etc. For dramatic effects, the key light can be moved farther to the side, the backlight increased in intensity, or the fill light brought down in intensity. All, or any combination of the above, can be used for a dramatic effect.

Care must be taken to match your lighting with the light fixtures and other light sources in the scene. If there is a lamp or other lighting fixture in the frame, it is usually necessary to key a light from the same angle. If this is too difficult, or even impossible to accomplish with the key light, a secondary key should be used. A narrow flood or spot should be placed out of the frame on the same axis as the lamp or fixture. Its ratio with the primary key, when read in the immediate vicinity of the lamp or fixture, should be on the order of one to one. Another means of accomplishing the same thing is to replace the low-output light

bulb in the lamp or fixture with a 300- or 500-watt bulb. Your eye will tell you which to use.

There are times when it is either desirable or unavoidable that windows be in a scene. During daytime hours, however, window light reads as blue on tungsten film. The scene as perceived through the window, being lit by daylight, will also be blue. This presents a color-balance problem. The most expedient way to solve it is to load your camera with daylight film (activate the conversion filter in Super-8 cameras) and either use daylight blue photofloods for your interior lighting or dichroic daylight conversion filters over your quartz lights. This will equalize indoor and outdoor color temperature. If the daylight entering the window is too bright, it can be cut down with drapes, or with transparent neutral-density gelatin filters, which come in large rolls available from cinema supply houses. The material is cut to size and mounted very carefully on the window itself. Neutral-density rolls come in various grades. If you are interested in only the light coming through the window, rather than the view outside, any kind of white diffusing material, even tissue paper, will suffice. Simply tape the material neatly to the outside of the window. If, however, you wish to include the outside view in your scene, an exposure ratio of two to one is all the tolerance you'll have. The outdoor light must be within one stop of the indoor lighting.

More than one key light can be used, and usually is, in scenes where the subject's actions encompass an area too large to be covered by one key light. The key lights must appear to come from a common source, or must be "justified" by the lamps, lighting fixtures, and other light sources in the room. Naturally, there are exceptions.

Initially, however, I suggest that you keep your lighting as simple as possible. Work with as few lights as you can get by with, and watch out for shadows on walls and floors, as they can cause no end of problems. Multiple shadows are particularly bad and difficult to deal with.

To help control shadows and light spill, you can easily make a

"cookie," which is nothing more than a piece of dark cardboard, cut to suit the situation, and placed in front of the light so as to shield specific areas of the set.Cookies are easily attached to light stands with clamps or tape.

Diffusers are used to cut down and soften the light from any given source. Various kinds are available, but you can easily make your own out of fiberglass. Mount diffusers a few inches in front of the light, and keep in mind that photographic lights give off a great amount of heat. A flammable material used as a diffuser is likely to result in a three-alarm fire. There are a number of different devices manufactured for mounting diffusers.

Diffusers also work well for softening light. When used over a key light they lower the amount of fill necessary and soften hard shadow lines.

"Barn doors" are devices which attach to most photographic lights in order to restrict the light spread. They consist of two black metal shields hinged like doors, hence the name.

Electrical Power

The maximum amount of light you can throw on a scene is in direct proportion to the amount or amperage of electrical power available on the premises. The fuse or the circuit-breaker box can give you this information. If there is more than one fuse or circuit breaker, this indicates that there is more than one line. If so, you are in luck, but first you must determine which line feeds which outlets. It's a simple matter to pull the fuse on each line, and observe which outlets become inactive. This done, you can now split your power requirements between the lines available to you.

To determine the power requirements of your lighting equipment, divide 100 into the rated wattage. Thus, a 500-watt light will draw about 5 amps (this is a rule-of-thumb formula, so allow some leeway). For example, if the rated amperage of each of three available lines is 15 amps, you have a total of 45 amps at

your disposal, provided that you split it up evenly. Ideally, this would allow you to use nine 500-watt photo lights, or possibly seven 650-watt quartz lights. However, you must allow yourself some margin for error, and also allow for other electrical equipment on the premises, such as refrigerators, room lights, radio, etc. Therefore, you'll have to be satisfied with eight 500-watt photo lights, or six 650-watt quartz lights, or their equivalents. To be on the safe side, even after making allowances, you should turn off all the unnecessary room lights and electrical appliances.

Chapter 10

FILTERS

PHOTOGRAPHIC filters for motion-picture use are disks of optical glass of varying colors and intensities which are screwed into, or otherwise mounted on, camera lenses. Light, passing through the filter, is therefore modified in terms of brightness and color before striking the film. All filters, because of their density, result in some light loss, often an insignificant amount.

Conversion Filters 85, 85A, * and 85B

As discussed earlier, Super-8 cameras have a movable, built-in filter, which converts the 3,400° K balance of Type A tungsten film to accept the 6,000° K of daylight. This is an 85A filter, salmon colored, with a factor equaling an exposure loss of about two-thirds of an f-stop. Screw-on 85A filters are available for use on Single-8, Standard-8, and Double-Super-8 cameras.

When you are using film with a 3,200° K balance, such as Ektachrome EF, an 85B filter is usually recommended. However, the difference between 85A and 85B is minimal, equaling only 200° of Kelvin temperature, which in ordinary daylight conditions will result in only a very slight blue shift in the film. But, if you are a purist and are using Ektachrome EF or any other 3,200° K film outdoors, you should deactivate the 85A conversion filter built into your Super-8, and use an 85B filter in its place.

*The designations 85 and 85A are different manufacturers' designations for the same filter types.

111

At times a sky-light or haze filter can serve a valuable second function by protecting your lens from dust, smoke, water, etc.

The primary advantage of using tungsten film outdoors with a conversion filter is that only one type of film need be stocked or carried. A conversion filter obviates the necessity to switch a partially used cartridge when you are moving from a daylight to a tungsten situation, and vice versa.

Conversion filters 85 (85A) and 85B can also be used in *black-and-white* photography, though their function has nothing to do with "conversion." Because of their orange color, these filters absorb blues and blue-greens, rendering them darker. They are excellent for darkening sky and water and emphasizing clouds and spectral reflections. They also serve well for aerial cinematography and astrophotography by "cutting through" haze. They are not recommended for flesh tones. Conversion filters are therefore multipurpose, and the fact that they are built into Super-8 cameras makes them even more convenient.

Haze, Sky-Light, and UV Filters

These are used to reduce the excess blue, usually caused by ultraviolet, in haze and open shade. The conversion filters discussed above have inherent in their formula a measure of ultraviolet filtration, but it is minimal, and additional filtration is not a bad idea under certain conditions. Therefore, a haze #1 filter is recommended for landscapes, when you are shooting outdoors with tungsten film through an 85 series filter. For open-shade photography under the same set of conditions, a sky-light or sky-1A filter is recommended. For ultraviolet correction on daylight color and black-and-white films, refer to the charts on pages 198-201.

Natural-Density Filters

When you are using high-speed films outdoors, where the minimum f-stop on a given camera is not small enough to stop down adequately, a neutral-density filter is required. This also serves the purpose of decreasing the depth of field in order to facilitate selective focusing.

Neutral-density filters are colorless. They may be used with black-and-white or color films and come in a variety of densities.

Polarizers

Polarizers, or polaroid filters, can be used in the same manner as neutral-density filters. They generally require a two-stop exposure increase and are neutral in color. Two polarizers screwed together become, in effect, a variable neutral-density filter, providing an initial 16X factor (minus four stops). If you rotate one filter inside the other, the light decrease is continuously variable all the way down to total blackout, an excellent way to accomplish fade-outs and fade-ins. For more basic functions of polarizers, see the charts on pages 198-201.

Star Filters

Used to create starlike patterns in highlights. These special-effects filters are most effective when lights or spectral reflections are in the picture. They come in three star sizes, from 1mm to 3mm, and may be used in combination for black-and-white or color. They are a touch of fantasy, particularly where street lights appear in the scene.

Fog Filters

For fog effects. Fog filters are of neutral color and come in four densities for color or black-and-white film. When used properly, they are quite capable of simulating or exaggerating actual fog. Some manufacturers also make fog-effect filters which cover only half the disk and can be used to simulate fog on the upper or lower half of the frame. Since their purpose is to create or

The combination of one-stop underexposure and a CC15-B filter can simulate night on daylight color film.

heighten the effect of a foggy day, they should never be used in sunlit conditions, as the results would appear artificial.

Color-Compensation Filters

CC filters come in several densities in each of the primary colors: red, blue, and green (additive primaries); and the secondary colors: magenta, cyan, and yellow (subtractive primaries). In use, CC filters may be combined to create any conceivable tint. They are very useful in creating mood effects. These filters are available in gelatin and are quite inexpensive. Photo dealers also carry inexpensive gelatin-filter holders, which further simplify their use. Care must be taken to preserve their surfaces. Beware of even less expensive Color Printing (CP) filters in acetate form, as they are not made to be used with cameras and may degrade or diffuse the image. CP filters are for color film only.

Soft-Focus or Diffusing Filters

Soft-focus filters blend shadows and create a halo effect in highlight areas. They minimize blemishes and rough skin texture in closeups, and they diffuse and soften backgrounds. They impart a feeling of luminosity and are especially significant in side- and backlit scenes. The effect is created by dispersal of highlights into the shadow areas by means of light diffraction. They are lovely for closeups, love scenes, scenics, night scenes, nudes, dream sequences, flashbacks, etc. Soft-focus filters come in two types: random and concentric. The random type retains the same degree of diffusion regardless of f-stop. The concentric type varies the amount of diffusion relative to lens aperture. The random type is recommended for S-8 use.

Filter charts listing most of the available types of filters may be found in the Appendix.

Chapter 11

CAMERA MOVEMENTS

AS with everything else, camera movements must have a purpose or a function in a film. It seems to be an automatic assumption on the part of beginning film makers that since they are involved in *moving* pictures, just about everything has to be *moving* all the time. Wrong! Nevertheless . . .

Tilts and Pans

A pan (*pan*oramic shot) is accomplished by the turning of the camera right or left, around its vertical axis. A tilt is accomplished by the tilting of the camera up or down. Panning and tilting can be combined.

Panning is best accomplished with the camera mounted on a sturdy tripod. If no tilting is involved in the pan, it is best to lock the tilting mechanism. Pans must be smooth—this is a cardinal rule. When possible, it is advantageous to overcrank when you are panning. A filming speed of 24 fps is quite practical, provided there is no subject movement in the shot which might be adversely affected by the slight slow-motion effect. Keep some tension on the tripod panning and tilting mechanisms by tightening them somewhat. This provides something to "work against," so the pan or tilt won't get ahead of you.

With the legs extended, a tripod should be sturdy and surefooted, and the center pole extension should be down and locked

while you are panning (center poles are usually shaky devices). If you must do your panning and tilting hand-held, so be it. Keep your elbows pressed into your body, and the camera jammed up against your head. Twist from the waist, with your feet firmly planted on the ground. When tilting, try not to move the camera independently of your body. Use your neck and upper torso to supply the tilting motion. If possible, keep the focal length short, as there will be less chance of camera shake.

Pans should be in one direction only. A film camera is not a water hose. Don't treat it as one. If you are panning from right to left, don't reverse yourself in mid-shot. It can be terribly disconcerting to an audience. The same applies to tilts. You can, however, tilt up at the start of a pan, and then tilt down later, toward the end. This works well as a subjective searching device, provided that it pays off in something significant relative to your film, at the conclusion of the tilt down. When combined with a fast zoom-in, it makes for a strong payoff. The audience will be aware that the camera has found what it's searching for.

There are five types of pans: the scenic pan, the resolved pan, the simulated "trucking" pan, the follow pan, and the swish pan.

1. *The Scenic Pan.* This is always a very slow panoramic shot and is sometimes used to establish the locale.

It is not necessary to resolve this type of pan by ending it with a static hold on the scene. The shot can commence and end with the camera moving. Keep it slow and uncomplicated. Unresolved scenic pans work well with fades at both ends, and work even better with dissolves. In fact, a series of unresolved slow scenic pans, connected with lap dissolves, can be very beautiful indeed.

If you are combining a pan with a tilt, keep in mind that the audience will see it as a diagonal movement on the screen.

Scenic pans, of course, are quite important in travel documentaries. However, don't overdo it. It is easy to fall into the trap of repetitive pans of this type (all that beautiful scenery). In many cases, a series of static shots will "read" much better and give your audience a chance to "digest."

2. *The Resolved Pan.* If you pan from one object or subject to another, it must "pay off." In other words, there must be a reason for the pan. It should be a fairly important reason. For example, if your hero sees or becomes aware of something out of the camera range, a pan is a useful device for revealing what it is. This is a very subjective technique, and like most special camera movements, it should be used sparingly.

Another use of the resolved pan is to make clear to the audience the special relationship between two subjects. This is sometimes done if there is not enough room for a single wide shot. However, its main effectiveness is in the creation of suspense, which is directly related to how long it takes to resolve. On the way, the pan can also allow the audience to appraise all that lies between. This is a technique that can create considerable suspense. (Hitchcock is the master of this type of shot.)

Panning back and forth, either in single shots or repetitively in a series of shots, is not recommended.

Small critters are best shot from their own level.

The resolved pan should *resolve*. To put it simply, it should come to rest on its goal and stay there a while. It is traditional also to *start* the pan from a static shot. Naturally, as with most rules and traditions, this one exists to be broken on occasion. Make certain, though, that when you break a rule it pays off. Put another way, if it works, do it.

3. *The Simulated Trucking Pan.* You accomplish a trucking shot by attaching the camera to any sort of wheeled vehicle (or dolly) and rolling it while shooting. Usually, trucking shots consist of moving the camera in a line parallel to the subject. Let us say, for example, that you have a person walking down a country road. A true trucking shot would be difficult here because of the uneven ground (you would have to build a track for your dolly). Ordinarily, a normal pan shot of this action would show the subject from a front angle as he approached the axis of the pan, and from a rear angle as he passed it. It would be obvious that the camera had been rotated around a fixed point. However, if an extremely long focal length is used for the pan—say, in excess of about 55mm—and the lens is opened to as wide an aperture as possible (through the use of a neutral-density filter or a double polarizer), a simulated trucking shot is possible. The wide aperture is necessary in order to throw the background out of focus as much as possible, as recognizable background objects have a tendency to reduce the illusion of trucking. The longer the lens, the greater the length of time the illusion will be sustained. It is also important to include as little foreground as possible. To facilitate this, keep the subject close to the bottom of the frame. Under optimum circumstances, depending on the panning speed, a simulated trucking shot can be sustained for as long as four or six seconds.

4. *The Follow Pan.* A camera movement which, from a static position, follows a moving subject, is know as a follow pan. This type of pan shot is generally used more than any other and is certainly the easiest of all to motivate and execute.

When you are panning with a moving subject, it is advantageous to lead it somewhat. There should be a greater space in front of the subject than behind. The ideal is two-thirds in front, one-third behind. Practically, this allows you a little more leeway for accurate tracking, and psychologically it relieves audience tension by showing where the subject is going—they've already seen where he's been. To hold a moving subject up against the leading edge of the frame, though I've never seen it in a film, might create a feeling of anxiety and insecurity.

An interesting use of the follow pan involves the employment of transitional objects. A follow-pan shot, for example, of a ball rolling from point A to point B connects the two points in time and space. If the ball has been dropped by someone, and then picked up by someone else, the second person has then been introduced to the screen via a connective action. Birds in flight, leaves blowing in the wind, objects passed from hand to hand, etc., are all useful. However, when you use such devices, make sure that they pay off. The follow-panning of transitional objects is a means to an end, and not the end in itself.

5. *The Swish Pan.* This is a very fast pan, which propels the audience at lightning speed, once again from point A to point B, permitting the spectators to see nothing but a blur on the way. In filmic language it says, "Meanwhile, on the other side of town . . ." Actually, as I recall, the swish pan does seem to have been, at one time, Hollywood's ideal method of getting across town in New York City. It seems to me I've seen it a hundred times. As its length bears some relationship to the distance it propels its audience, crossing Manhattan is really just about the maximum distance that a swish pan can safely traverse.

From Boston to San Francisco, or from Seattle to Peking, might require a swish pan that is much too long to be taken seriously. Two seconds seem to be maximum—far too short to span the Pacific. The exception to this is the old-fashioned expediency of connecting both ends of a long-distance telephone call or radio transmission with a swish pan. (Ginger Rogers in

New York, speaking angrily into telephone . . . swish pan to London! . . . Fred Astaire with phone, trying to get a word in edgewise . . . swish! . . . Ginger Rogers slamming phone down.)

Swish pans can be edited into existing footage. It is simply a matter of shooting some stock, undercranked fast pans for intercutting purposes. The swish pan seems to have gone out of style, as have many other film devices. Today's filmically sophisticated audiences don't require the old, established cinematic cues to the same extent as their predecessors. (Meanwhile, on the other side of town . . .)

The Moving Camera

It was discovered quite early in the cinema's short history that a great deal of excitement is engendered when the camera itself takes wing and moves about. In the final analysis, of course, it is the audience that is actually being moved about. This was proved beyond any doubt, as many readers might recall, by the universal reaction of audiences to the roller-coaster sequence in the first Cinerama feature.

When a camera is mounted in a speeding automobile, it is the audience who will eventually be sitting there, nervously peering through the windshield. When the skier zooms down his slope, camera in hand; when the rider shoots film from his horse on the moving carousel; when the documentary film maker, with his camera to his eye, runs backward facing his quarry—all will result later in visually subjective experiences for those watching the screen. In some cases, as with the above, this experience can be emotionally vicarious; in others it might be more subtle. But even the shortest dolly shot results in a subjective audience reaction of some kind.

Filming from moving cars, airplanes, buses, trains, choppers, streetcars, or Apollo LM's presents some common problems. Bumps and vibrations, for instance, can create eye-shattering effects when the film is finally projected. If you overcrank (speed up the camera), a great deal of aberrant motion can be smoothed

Exposure was increased one full stop over reflected-light reading to compensate partially for brightness of landscape.

out, especially when you are shooting out the window. The more fps, the smoother the ride on the screen. Of course, when you speed up the camera, you slow down the action. In photography, you have to "pay" for almost everything. Therefore, if there are people in the frame involved in recognizable actions, a filming speed of about 24 fps is your limit. Faster than that is going to create a very obvious slow-motion effect.

When you are shooting at right angles from a moving vehicle, the apparent speed on the screen will always be double the actual speed. A film shot at 18 fps from a car moving 60 miles per hour, will, when projected at 18 fps, make the car appear to be going 120 miles per hour. This phenomenon permits you to speed the camera up to 36 fps, which not only slows the apparent motion back to normal, but also helps smooth out the bumps, one of the few examples in photography where you get something for nothing.

This phenomenon does not occur, however, when you are shooting from a moving vehicle with the camera pointed along the axis of movement, directly to either the front or the rear. At this angle, with a normal lens on the camera, there will be no

(*Thomas Yulsman*)

Distortion caused by shooting through the plexiglass dome of a helicopter. Such distortion can at times be pictorially interesting; however, if you wish to keep distortion at a minimum, use a rubber lens shade pressed up against the glass.

apparent speedup. However, with a wide-angle lens or zoom setting, the apparent motion *will* be speeded up, and over-cranking to smooth the bumps will reduce apparent velocity back to normal. A telephoto, however, will normally slow down apparent velocity when shooting head-on, and it will also further compound the problem by exaggerating bumps and other aberrant movements caused by a moving car, for in this case, the telephoto acts like an optical lever: a small movement of the camera results in a large movement of the lens. Overcranking in this case will naturally have a tendency to smooth bumps somewhat, but apparent velocity will be reduced even more. For example, shooting forward or rearward through a 60mm lens at 36 fps from a car traveling in excess of 60 miles per hour will reduce the apparent velocity on the screen to less than 10 miles per hour!

The photograph taken from above indicates two different camera positions ("A" and "B") from which the street can be shot. Cutting from position "A" to position "B" in the same sequence would reverse the action (direction of traffic) on the screen. The audience would then be justified in assuming that they were seeing two different one-way streets. To prevent this kind of confusion, all televised football games, for example, are shot from the same side of the field.

Shot from position "A."

Shot from position "B."

When shooting through a window, keep in mind that unlike the rare earths and fine polishing and grinding techniques that went into the design and manufacture of your lens, window glass (or, in many cases, plexiglass) is usually of poor optical quality. To reduce the distortion, try to keep your lens as close to the glass as possible. If you intend to do much shooting of this kind, I advise you to purchase an inexpensive rubber lens shade. By forcing the rubber hood right up against the window, you will reduce the distortive effects of the glass and there will be no chance of the lens's picking up reflections.

See the filter chart (page 200) for suggested filtration to be used when you are shooting through tinted glass of the type found on vistadomes, etc.

When you are shooting interior scenes inside a moving vehicle, the camera will be bouncing around at about the same frequency as the vehicle itself. Therefore, if the camera is clamped or otherwise attached to the structure of the vehicle, all the aberrant movements will be "in tune," and there will be very little bouncing on screen. Passengers and other loose objects, however, will register the effects of a bumpy ride, as will the scenery out of the window.

There are situations in which camera movement is desirable, such as in boat cabins, where a rhythmic rocking of the camera will register on screen as a heavy sea.

A successful method for shooting into car interiors is to mount the camera outside the car, pointing through the windshield. This will usually entail the welding or bolting of a tripod mounting-screw onto the hood, an inexpensive procedure. The camera can then be controlled by a remote extension. The camera, so mounted, can also be faced around to shoot forward. Make sure when shooting into the slipstream from any type of moving vehicle that you protect your lens with a filter (either a clear filter, or, even better, a UV or haze filter).

Dollying in, or out, creates a much different result than zooming in or out. A zoom shot will always be two-dimensional in effect, as if the subject were a flat photograph. When you dolly

in or out, however, subject-camera distance changes and, therefore, perspective changes. Near objects appear to approach the camera at a greater speed than far objects. As an example, consider the view out of the windshield of a moving car. Close objects such as trees, houses, overpasses, etc., approach and recede at a rapid rate, yet the distance to the horizon or the far mountains seems to change only imperceptibly.

Thus, the three-dimensional dolly is even more subjectively effective than the two-dimensional zoom. This holds true in even the shortest, tightest situations.

When you are dollying, a follow-focus technique is usually necessary. (See Chapter 4, "Focusing.")

The best "homemade" dolly, usable for almost any type of moving shot, is a wheel chair. Just sit in it, arms braced, camera to eye, and have an assistant do the pushing. A common delivery wagon, though it is not quite as smooth or controllable, can also be used in this manner. You can also clamp your camera to a baby carriage, or even a shopping cart, and do your own pushing. If the vehicle—automobile or whatever—has inflatable tires, things go smoother if you deflate the tires somewhat.

There are times, especially when you are shooting documentary or pseudodocumentary footage, when "walking" shots are desirable or necessary. Moving about in a crowd with a hand-held camera can be very effective, as the camera movement will sometimes enhance the feeling of excitement and participation. When walking backward, make sure there are no deep precipices or lily ponds behind you, and if you are involved with a single subject, try to match your pace with his. Wide angle is your best bet, because of the inherent depth of field and lessened susceptibility to camera shake.

Chapter 12

THE SCRIPT

 SCRIPT requirements vary according to the type of film they deal with. Sometimes a script will consist of just a brief outline which does little more than remind the cinephotographer of the important aspects of a documentary situation. If, for example, you are going to produce a travel documentary of a place you've never been to before, your script might consist of a small notebook containing research material collected from travel books, etc., before you embark. Prior to shooting, you might also spend a few days doing personal research on location, thereby extending your notes. Anything more than that—say, a complete shooting script—might actually prove to be a hindrance by restricting your freedom to make use of interesting and important subject matter you become aware of as you proceed.

A comprehensive shooting script is actually an impossibility for any kind of *off-the-cuff* shooting, such as sports, nature films, and other types of spontaneous action. This of course does not eliminate the necessity for research. For example, if you were to do a film on a football game, you would arm yourself with data about the two teams, much the way a reporter would. In these situations your finished script should actually be written after you have seen and become familiar with all the processed footage and you are ready to start editing. This is known as an "editing script," and is described in the chapter on editing.

Shooting scripts are used in situations in which the director or cinephotographer has complete control over most of the elements of his production. They contain information about every aspect of the production: dialogue, actors' cues, camera angles, locations and sets, props, sound effects, lighting, etc.

On page 130 is a section of a typical shooting script dealing with a single sequence. (A sequence is a series of interrelated scenes or shots, much as a paragraph is a series of interrelated sentences.) Shooting scripts vary extensively, and this example demonstrates one of many possible forms.

You will notice in the example that all the scenes in a shooting script are numbered consecutively. One reason for this is so that they may be *slated*. Slating is done just before a scene is to be shot. The scene number corresponding to the one on the script, and the take number indicating how many times the scene has been reshot, are written in white chalk on a small black slate (about one foot square). For example, if the scene to be shot is #98, the slate will be prepared to read SCENE 98 TAKE 1. Just before the scene commences, the slate is held in front of the camera and exposed for a few frames. If the first take fails, let's say because an actor misses a cue, then the next slate will read SCENE 98 TAKE 2, and so on. When a successful take has been accomplished, its number is entered into the script next to the scene number. When you are editing the processed film, it becomes a simple matter to refer to the script for the best take of any given scene and then locate the corresponding scene on the film by checking the slate numbers preceding each scene.

When you are working from a shooting script, it is never necessary to shoot in sequence. Scene #94 in the sample, for example, is an insert which would be shot at a different time, and quite possibly a different place. To save time and effort, all the scenes from the complete script which have Bruno in the Main Hall would be shot at the same time, regardless of the scene number. In fact, if proper planning is used, a script can be broken down, so that all the scenes occurring on any given set or location, *regardless of the cast,* are shot at the same time. And

Section of Shooting Script

PICTURE	AUDIO
91. Interior castle, night. L.S. Main Hall, a fire in the huge fireplace provides key light and throws grotesque shadows. Hold 5 sec. Then, the hunchback Bruno enters carrying candelabra through far doorway. CUT TO:	Distant sounds of thunder. Hold through scene #126.
92. Int. castle Main Hall. M.S. Low angle, Bruno. He moves toward camera. CUT TO:	Wolf howl. Hold under through scene #93.
93. Int. castle Main Hall. C.U. Bruno. He is startled. His eyes dart from side to side. CUT TO:	Bruno: (under his breath, a whisper) Gorgo!
94. Ext. castle grounds. L.S. A flash of lightning momentarily reveals the distant silhouette of a howling wolf. CUT TO:	Wolf howl up.
95. Int. castle Main Hall. C.U. Bruno terrified. CUT TO:	Wolf howl. Hold under through #102.
96. Int. castle Main Hall. L.S. Bruno hobbles toward fireplace. CUT TO:	Bruno: (under his breath) No master! No!
97. Int. castle Main Hall. C.U. Bruno terrified. CUT TO:	Bruno: Bruno go . . . now.
98. Int. castle Main Hall. Trucking shot. Bruno. He hurries to fireplace and presses a hand against the interior wall. CUT TO:	
99. Int. castle Main Hall. C.U. Bruno as he presses hidden brick in fireplace wall. Slow zoom back to L.S. as hidden passage opens in fireplace through which Bruno disappears. The secret passage closes after him. CUT TO:	

Abbreviations
Int. — interior
Ext. — exterior
L.S. — long shot
M.S. — medium shot
C.U. — closeup

within that context, all the scenes occurring under the same lighting setup (regardless of scene numbers) are shot, before the lighting is changed. This is the most economical way to follow a shooting script. You finish completely with each setup before moving on to the next. It saves running around from set to set.

To break down a script for this purpose, it is best to use a series of "3x5" file cards indicating location, cast, lighting, and scene number. If you place these cards in *shooting order* rather than *script sequence,* it becomes much easier to keep track of things. Such a series of file cards is not meant to replace the script, but just to augment it during the actual shooting. Once the cards are arranged in the order in which the scenes are to be shot, it becomes much easier to refer to the next scene without having to thumb back and forth blindly through countless pages of shooting script looking for it.

In writing a script, it is well to remember that most successful stories have basically simple plots. The essence of the plot of almost any work of fiction can be summed up in one short paragraph. The complexities are a function of character development, secondary story lines, descriptive details, etc.

Start with a simple one-paragraph skeleton digest of your story. From this, the next step should be the development of a synopsis. The synopsis should be the bare bones, expressed in the present tense, of just what will be shown on the screen, the story as the audience will see it. Keep in mind that you are not dealing with a literary work. Writing style and form are not important. Will it work on the screen? Can the idea be expressed visually, photographically, or through the talents of the actors?

A few pages should be adequate for your synopsis. The next step is to break it down into a shooting script. The synopsis describes the plot and characterizations; the shooting script tells you how to get it into the camera and onto the screen. It must contain all the elements needed to produce the final work. The cameraman will depend on it for lining up shots. The sound man will depend on it for sound cues. The actors will use it for lines and stage directions. The lighting man will need it in order to

light for the appropriate time, place, and mood. And finally, the film editor will use it to establish continuity. Of course, it is quite possible that you yourself might carry out most of these functions (except the acting).

Story films are possible to produce without the use of a shooting script, especially silent films. However, they will usually be more wasteful of time and film stock in an effort to cover all the contingencies and supply enough footage for the editing procedure. Nevertheless, it can be fun to work with something less than a *complete* shooting script in order to take advantage of spontaneous ideas and improvisation.

III

IN THE CAN

The shooting is complete. All the short pieces of the film, end to end, lie in their cans waiting to be assembled into a single, coherent entity.

Chapter 13

EDITING

IT is the opinion of many (particularly film editors) that editing is by far the most creative part of the entire filmic process.

Film editing actually encompasses much more than merely the splicing together of takes into a single continuity. The very essence and meaning of a film can be enhanced, changed, or distorted in the editing procedure. In no other art form does the editor have the power to impose as much of his own interpretation and style on the end product. And it is a fact that in the olden days of the "moguls," many a Hollywood director was literally locked out of the cutting room.

Commercial films are rarely shot in the sequence in which they are to be shown (with one important exception, *Rope,* by Hitchcock). Scenes which were shot thousands of miles and many years apart are often juxtaposed to form smooth continuity.

Film making creates its own time-space continuum. It is magic. Three minutes on the screen can encompass hours, or days, or even years of subjective time, or a two-hour movie can examine five short minutes in minute detail. Flashbacks and even "flash aheads" can shift and distort the continuum into a veritable Mobius strip. The film-editing procedure is a fascinating time machine.

The creative aspects of film editing can be overwhelming to the beginning virtuoso. Good editing should be, in a sense, invisible. Audiences do not notice good editing; if they did, it would indicate that it was getting in the way of the film.

To get the feel of the possibilities, shoot the following: (A) A closeup of a seated man, relaxed and thoughtful. He looks downward. Cut. (B) A second shot of the same man from the same angle, a soft smile on his lips as he looks up. Cut. Shot (A) should run for about six seconds, shot (B) for about four seconds. Now shoot a foot of film on both of the following: (1) The remains of a meal. (2) A dead woman, lots of ketchup, maybe a bloody knife by her body.

For your first audience reaction, splice shot (1), the meal remains, between shots (A) and (B). Your audience will probably agree that this is a short sequence of a happy, satisfied gent, who has just finished eating a delicious repast. Great acting. Let things ride, and the next time you have an audience, remove shot (1) and intercut shot (2), the body. With equal certainty, your new group will insist that here is an evil, psychotic man who has just murdered his wife. "Fantastic performance, beautifully underplayed!"

Shooting for Editing

The length of individual scenes (shots) in an edited silent film should vary from about two to twenty seconds. Most of the time, scenes longer than ten seconds seem interminable. There are some exceptions though.

Scenes should be shot, at least in part, three or more times, with different angles and framing (image size in finder), so that they may be cut into individ·ial scenes.

When two scenes, sharing the same action, but shot at different times, are to be cut together into a continuous sequence, make sure that lighting and general details, such as clothing, props, etc., match in both scenes. If there are minor discrepancies, try separating the shots with a long cut-away, (reaction shots, closeups of the action, details, etc.).

In the photographing of real life or documentary situations, *no* amount of footage is too much. Shoot as much cut-away material as possible, as it will be needed in the editing procedure.

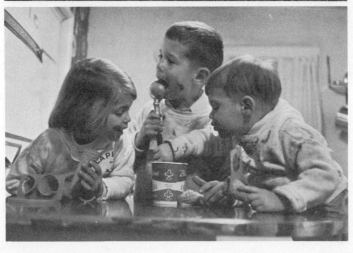

If possible, have someone operate a second camera from another angle to supply footage for later intercutting. In many documentary situations, this can be a lifesaver. The second camera can be fixed with a high, wide view of the overall scene. Once it is set, it becomes a simple matter of pressing the button and reloading when necessary. Your assistant will require no photographic talent. This two-camera system enables you to roam and shoot freely with the knowledge that you are covered for long shots.

What follows are some standard editing procedures. I suggest you learn them before attempting to invent some of your own.

The Match Cut. Match cutting is used to create a single continuity involving subjects and action in a linear time procession. Match cutting works best when made on movement. Some examples: *a pole vaulter*—side view as he approaches the top. Cut to front view as he clears the bar. *A person entering an automobile*—exterior view as he opens door and starts to enter car. Cut to interior view while he is still in the process of entering. *Person walking out of front door*—interior shot as he approaches door. Cut as he gets halfway through door to exterior shot showing him halfway out.

Make sure to shoot more footage (both fore and aft) of the action that you think you are going to need, so that you will have leeway to choose the exact point in the action which cuts best. Clothing, facial expressions, hands and feet position, etc., should be watched closely for mismatches.

One of the major bugaboos of match cutting is the jump cut. This is a goof that usually occurs when the match cut does not quite match! Visually, it is a small jump in the action often caused by too slight a change in point of view. A subject will suddenly appear to be three feet closer to the camera than he was an instant ago, or a closeup face will radically change expression in what seems to be the middle of a hiccup. To safeguard against this devil, try to make your cuts with a somewhat radical change of angle. Cutting on motion, as explained earlier, will also help considerably. If all else fails, and you didn't supply yourself with

adequate footage for a proper match cut, you can always resort to a cut-away.

The Cut-Away. The cut-away is a means of cutting away from the primary action to insert a related shot without creating an obvious change in subjective time. Cutting from a pair of boxers in the ring to an audience reaction shot is a typical cut-away. When you cut back to the boxers, it is not necessary to match actual time. You can, with impunity, cut into a much later action in the fight, therefore actually shortening the playing time, or, conversely, you can lengthen it by cutting back to where you left off. The cut-away is an ideal device for compressing or contracting the screen time of any extended action, without the dangers of jump cutting.

The Insert Shot. The insert is used to show the audience an action or detail related to the main continuity, usually from the point of view of the subject. Someone reading a letter, followed by a closeup shot of the letter, is considered an insert. (For smooth continuity, you should cut back to the reader, just as he finishes the letter.) The experiment earlier in this chapter, involving the finished meal and the murdered girl, is a good example of the insert shot. Inserts (and cut-aways) can be shot at a time and place different from the main action or can even be taken from stock (library) footage you have accumulated.

Parallel Editing. Intercutting two or more lines of related continuity is called "parallel editing." Cutting back and forth from the train to the car as they both approach the crossing is a somewhat basic example of this. Parallel editing almost always results in a single time continuum. Example:

1. A building on fire.
2. A man escaping from the building.
3. The fire.
4. The man running down the street.
5. The fire.

6. The firehouse, firemen lounging around, playing cards.

7. The fire.

8. The man running up to an alarm box.

9. The fire.

10. The firehouse Dalmatian twitching in sleep.

11. The fire.

12. The man pulls the alarm lever.

13. Closeup of ringing alarm bell in firehouse.

14. Man continues to pull lever.

15. Firehouse dog wakes up.

16. Firemen run to their enginers.

17. The fire.

18—25. Intercutting between fire and fire engines as they race to the scene.

This is an example of parallel editing involving three simultaneous lines of action. The sequence is quite basic and no doubt is part of at least a thousand films from the silent era. However, parallel editing can be quite sophisticated and does not necessarily have to deal with obvious "races against death" or time.

Entire films have been edited with two or three or even more separate lines of action, running almost the entire length of the movie. An example of this is a documentary film titled *Jazz on a Summer Day,* which intercut the Newport Jazz Festival with the Newport sailing regatta. It worked.

Long Shot, Medium Shot, and Closeup. This is the standard classic pattern. A long shot used to establish the locale and the subject's relationship to it, a medium shot (subject filling the frame) to introduce the characters, followed by an intimate closeup. The medium shot is the most important in that it carries

most of the action. There are films which repeat this pattern ad infinitum, a bore, like a monotonous regular beat. However, it has its value, particularly as a discipline from which to deviate.

The idea of using an establishing shot to introduce a sequence is a good one. It tells the audience just where the action is taking place. The original reason for then going to a medium shot of the subject before the closeup was to reduce the visual shock to the audience and make for a smoother transition to the closeup. The problem with this classic sequence is that film makers began to use the combination all the time. "You can't go wrong if you follow the rules." Horseradish!

Another classic method is to introduce the character and/or the main action with a short series of medium shots and closeups followed by an insert or a cut-away from the subject's point of view. Sometimes the insert is a long shot used to establish the locale. One such sequence is then followed by a similar one, each ending in another insert or cut-away, and so on. Each sequence culminates in a subjective insert or cut-away, usually a reaction shot. The Russians developed this now classic pattern back in the silent days, and it worked beautifully, but as with the three-shot sequence described earlier, it is a bore when repeated and repeated. (For an exciting exception to this, I must again refer to Hitchcock, this time *Rear Window,* which was cut almost entirely in this manner.) Both methods have their uses, employed repetitively, but there is a point at which their rhythm sometimes lapses into monotony.

Short Takes and Long Takes. As a general rule, excitement is engendered by a series of short takes, while long takes tend to be more tranquil. A scenic or a love scene, for example, can be played with takes running as long as 10 to 15 seconds. Conversely, a documentary of a riot or a karate match is best portrayed in short takes of from 20 to 50 frames.

To build tension it is sometimes effective to start with relatively long takes, cutting them shorter and shorter as the climax is approached.

A three-frame cut is about as short as can be managed in the S-8 format.* A series of three- to five-frame cuts can be fun to do and is quite exciting when projected. For such short takes, the subject matter should be graphically simple and devoid of confusing background. The length of a sequence of quick cuts can be from about two to ten seconds. Ideal subjects are discothèque dancers, electric and neon signs (such as on Broadway or in Las Vegas), closeup reaction cut-aways following exciting football plays, police and/or demonstrator closeups at demonstrations, flag carriers at parades, etc.

Put the short scenes together into a sequence, and treat the resultant length of film as a separate shot or scene, to be cut into the film as a unit. It is preferable to use a wet splicer for takes shorter than eight frames.

Fades and Dissolves. Originally, the fade-out-fade-in technique was developed to indicate a passage of time between sequences. A long fade indicated a long passage of time, and a short fade a short passage of time. This artifice was accepted immediately by audiences and quickly became part of film language. One of its earliest uses was in D. W. Griffith's *Intolerance.*

In recent years, both devices have been passing out of use, especially in feature films. Audience sophistication is the reason. It is assumed that today's film viewer no longer needs it "spelled out for him." That is true to a point, but surely the reader will agree with me that in many cases the editor has been a little more "sophisticated" than his audience. There has been a spate of films in recent years which confuse the audience about time and place and complicate simple story lines to a point where hardly two people in the audience can agree on the "meaning" of the film. Even the pundits and critics find it hard to agree at times, and perhaps the directors and editors intend such ambiguity.

Admittedly, we all understand film language better than we

*Two frames is the minimum that can be perceived. A one-frame cut is "subliminal" and is not consciously visible to the viewer. For a while it was used to advance the unconscious suggestion to theater audiences to buy popcorn.

used to, and it is *not* necessary to "spell it out" all the time, but it is necessary some of the time. As, for example, when a straight cut misleads us into thinking that the action is continuing on the same time track, and the film maker gives no other cues to correct the impression.

A lap dissolve is a cross-fade. While scene #1 is fading down, scene #2 is fading up. By the time scene #2 has faded up fully, scene #1 has faded down completely. Therefore, when you are creating a dissolve in the camera, if for some reason a retake is necessary for scene #2, then both scenes #1 and #2 require a retake because they were connected via the lap dissolve. Another drawback is that S-8 scenes connected with lap dissolves have to be shot in sequence, a hardship when you consider the changes in location, sets, etc. Therefore, shortly after the introduction of fades and dissolves into the language of film, it became necessary to find a way to make them subsequent to the shooting. Today, professional 16mm and 35mm film makers have their fades and dissolves made in the laboratory via optical printing techniques. The S-8 photographer-editor has (at this writing) no such luxury. He has to do it the way Griffith did, in the camera.*

You can make fades on cameras having variable shutters by gradually reducing the shutter aperture.

Another method is to use two polarizers. To fade out, start at the point of greatest light transmission and gradually rotate one of the two polarizers, through 90°, until light transmission is zero. To fade in, use the opposite procedure. The polarizer method, however, will not work in low-light situations.

There are fading devices available which make use of a sliding or rotating graduated neutral-density filter. They work in all lighting situations.

For making dissolves in cameras with backwinding facilities, use any of the above-mentioned methods for fading out at the

*One exception: A Chicago firm recently announced the availability of these and similar professional services for S-8. Write to George W. Colburn Labs, Inc., 164 N. Walker Drive, Chicago, Illinois 60606.

end of the scene, then backwind half the distance into the face and shoot the next scene starting with a fade-in.

Certain S-8 cameras offer automatic fade and dissolve devices. Griffith would have been delighted with the autofade on the Minolta D-10 and a few other S-8's, which enables the cameraman to preset his fades, so that they occur automatically at the start and finish of each scene. As for lap dissolves, the Bauer Company, taking advantage of a hitherto overlooked idiosyncrasy of the Super-8 cartridge, have not only managed to design a line of cameras with a limited (90 frames) backwind capability, but they've even produced a semiautomatic device which practically makes lap dissolves on its own.*

Fades and dissolves used to indicate time or locale changes are placed between sequences (a sequence usually is a series of shots or scenes which express a complete statement).

When you suspect that a shot might be used to begin or end a sequence, it is a simple matter to start or end it with a fade. If you decide later, during the editing procedure, that you do not require a particular fade, just cut the fade footage and dispose of it.

If, when you are dealing with the passage of time, there are cues in the footage, as, for example, a daylight sequence followed by an evening sequence, a fade-out fade-in is not necessary between the two.

Dissolves, in S-8 photography, since they currently must be made in the camera, have a somewhat limited application. They cannot be inserted during the editing procedure, so, therefore, must be planned before the shooting begins. This is much easier to do if a dissolve indicates a series of short pauses rather than a long break. Such a reiterated-dissolve technique can be used to tie together individual scenes of flowers, faces in a crowd,

*At this writing there are just a few Super-8 cameras available besides the Bauer C. Royal with the limited backwind capability necessary to make lap dissolves. There is, however, a complete line of Fujica Single-8 cameras with total backwind capability. All of the available Double-Super 8's also have total backwind capabilities, as do many Standard-8 cameras which can be purchased secondhand.

scenics, love scenes, sailboats, etc., or to delineate various facets of individual objects or people. Individual dissolving scenes can be connected with a common unresolved zoom, pan, or slow-motion effect, or even a combination of all three, with beautiful results. Coming out of one slow dissolve directly into another, in a series of five or six or more, provided the subject is right, can serve as a kind of poetic montage.

Dissolves used in the above manner serve literally as "commas," connecting together parts of a sequence.

Chapter 14

CUTTING

THE actual physical procedure of film editing is called "cutting." The requirements are as follows: a quiet, clean area to work in; a bench or table, six feet or more in length; an action viewer with rewinds; a packet of 3"x5" cards; a splicer; a rigged "clothesline" on which to hang film takes; a goodly supply of clothespins or spring clips; a magnifier or jeweler's loop; a red grease pencil; a number of empty 200- or 400-foot film reels; sharp scissors; a waste basket; a considerable amount of time; and an inexhaustible supply of patience.

Splicing

There are essentially two types of splicers for Super- and Standard-8: wet and dry. The wet splicer uses film cement or solvent. The emulsion on the cut end of one of the two pieces of film to be joined must be scraped off carefully, down to the film base, before the splice can take. Wet splicers usually have built-in scrapers, and a few currently available have motorized scrapers, which ensure a very accurate job. Cement splices are usually quite strong if made properly. Their advantage is that they affect only one frame of the film.

Mylar tape splicers (dry) work with pieces of specially for-

mulated "invisible" tape. Tape splices are the easiest to make, and are quite satisfactory. At this time, only tape splicing will work with Single-8 film, whose Mylar base will not respond to wet splicing. A tape splice should be made on both sides of the film. Tape splicing is "butted," that is, the two ends of the film are butted up against one another, whereas wet splicing involves a small film overlap. A current exception is a wet splicer made by Eumig, which uses a special film solvent and creates super-strong serrated butt splices (Eumig Chemo Splicer). Butt-spliced tape passes through the projector a little more easily than does the small lump made by overlap wet-spliced film.

Tape splicers and wet splicers must both be kept clean of "gook" which can foul up the works. The built-in knife edges on both must also be cleaned from time to time.

Action Viewers

Action viewers are devices for viewing film during the editing procedure. They include a pair of rewinds on which film reels are mounted, a screen, and on some models, a built-in splicer. My advice is to purchase the splicer separately. The screen size of your viewer should be at least 2"x3", and a focusing mechanism is absolutely necessary. Make sure your viewer also has a built-in marking device so that the frame you see in the screen can be marked without a hassle. Motorized action viewers are a waste of time and money.

A Step-by-Step Procedure for S-8 Film Editing

1. Review all your footage in a projector running at proper speed (18 fps). Repeat this a few times until you establish a general familiarity with the material.

2. Check your script against the footage you've got and make any script changes necessary because of shots not indicated in the original script, or shots which have been left out. If you have no

script, make a brief, loose continuity outline based on the existing footage.

3. Run all of the film through the action viewer. Use a grease pencil to mark the *head* or first frame of each scene with a consecutive number. Mark the corresponding scene number on a 3″ x5″ card along with a brief description of the cast, action, etc.

4. After all the scenes have been marked, cut them apart, and one by one hang the individual scenes on the "clothesline" (a newspaper or box under the hanging scenes will keep them from dragging on the floor), heads up.* Obvious outtakes go into the waste basket. Lay aside all blank film leader for possible future use.

5. Study your script cards and arrange them in continuity according to your script.

6. Start assembling (splicing) your film into a rough cut, corresponding to your card arrangement. Where you have more than one take for any given scene, choose the best one and lay the others aside for possible future use as intercutting material, cutaways, etc. If you're not sure of certain scenes, splice in some blank leader (from your collected stock, or if there's not enough, you'll just have to invest the price of a cassette of film. It should last quite a while). This is called a "slug," and it will remind you of the amount of action footage needed later. Make notes. You might also want to wait to intercut some of your inserts and cutaways until *after* you've seen the assembled film. Make a note of the scene number involved.

7. Attach titles fore and aft.

8. When your rough cut is completely assembled, add about a foot or so of blank leader fore and aft.

9. Check your splices.

10. Run the rough cut through your projector at normal speed

*Another method is to file the film takes in egg boxes. Number each compartment with the corresponding film scene number.

without stopping. This will give you a good indication of the continuity of your rough cut.

11. Using your action viewer, make whatever changes you think are necessary for continuity. You'll probably have to tighten up a bit.

12. Cut in all your remaining cut-aways, etc.

13. (Optional) If you intend to use narrative titles, now is the time to write and shoot them. See Chapter 15, "Titles."

14. You now have a finished motion picture. But have you? Lay it aside for a week, and then look at it again. I'm sure you'll find that additional tightening will help a little, along with a touch of this, and a dash of that. *Now* you're ready for an audience . . .

Chapter 15

TITLES

TITLES usually appear, as most everyone is aware, at the beginning or head of a film, to inform us what it is we are about to see, and whom we have to blame for it. At the end or tail of a film, there is of course the message "THE END."

The easiest and probably the most efficient method of lettering titles is through the use of press-on letters manufactured by Letraset or Presstype. Both are used extensively in the graphic arts field and can be purchased from almost any art supply shop. The variety of type available is staggering. The method is extremely inexpensive and simple to use. Alphabets come on transparent sheets and the letters are simply pressed onto the surface being used. There is also a wide variety of sizes to choose from.

There are many simple things which can be done to enhance opening titles. You can pan slowly (keep the lens long and overcrank) across the letters; you can zoom in on small type, creating the effect of approaching them from a distance; or you can zoom out from one letter to expose an entire sentence. You can mount letters on sheets of glass and shoot through them, shifting focus from foreground to background. You can do all these things and more, and if you have lap dissolve capability in your camera, you can connect it all together with long dissolves.

There are titling kits available which include rotating drums for making crawls, flip-flop boards for making flip-flop titles,

and all sorts of other goodies. Titles are fun to make. If you shoot white or light-colored letters against black, and your camera is capable of backwinding, you can even superimpose your opening titles on the film itself! Just shoot the titles, rewind, and shoot your first scene over them.

Most of the better S-8 cameras have closeup or macro capabilities, which can also be useful for fancy titling.

Explanatory Titles

The simplest kinds of explanatory title are signs, which already exist, such as street signs, road signs, airport signs, etc. Such natural indicators can pin down a locale and even supply a starting point for a useful pan.

Signs can be made and inserted when needed to give the dates and place names, or even the time of day, if important to the plot (if a convenient clock or watch cannot be cut in in a natural manner). Don't try to explain too much. Restrict title use solely to those explanations which cannot be expressed simply in any other way.

Fades or dissolves can be used with explanatory titles, and if your camera can be backwound, you can even superimpose them over existing footage.

IV

SOUND

Can anyone who has heard it ever forget that creaking tree in the graveyard scene from David Lean's *Great Expectations*?

Chapter 16

ADDING SOUND

Phonograph Records
The simplest way to add sound to an S-8 film is to play an appropriate phonograph record along with it. Music, when it matches, or points up the mood of a film, enhances its effectiveness. The choices, of course, are almost limitless. The results are quite gratifying, as more often than not the proper music will seem to fit almost perfectly. The final result is a silent film with musical accompaniment; it's as if you had an orchestra in the pit.

Tape
A somewhat more sophisticated method of adding sound is to prepare a sound tape by transferring music or effects from either a record or a tape original, to be played simultaneously with the film. This method is an improvement on the phonograph record in that editing is possible, and the music track can be recorded to approximate the length of the film.

In order to transfer music from a disc or tape original, a tape recorder or deck equipped with a phone or tape input is necessary. Either the reel-to-reel or the cassette type can be used,

but, because of the popularity of the tape cassette, subsequent instructions will relate to the use of that type of equipment. Cassette tape is more difficult to work with than reel-to-reel tape, so those of you with reel-to-reel equipment will find it quite simple to reinterpret these instructions for your use.*

Since we are *not* dealing here with actual sound synchronization, the following instructions are primarily concerned with creating a music track of the proper length and with timing it so that it begins and ends with the picture. Perfection is, of course, impossible without synchronization. How closely it can be approached with the following method depends on how well your projector maintains a constant speed each time it is used. Ideally, a two-second error in 50 feet (three minutes and two seconds) of film is about the best that can be hoped for. If part of this error results in sound before the picture starts, pass it off as a kind of minioverture. If it continues a few seconds after the screen has gone dark, the residual music will give your audience a few seconds of breathing time to recover from the profound emotional experience of your film. It's much worse to have your sound run out before the picture is over—leaves you hanging there.

The music at the end of a film should never end *abruptly* in midpassage. A fade-out is okay, but ideally the piece of music should come to its natural conclusion at the same time the film does. Here's how you do it:

1. Your choice of music should run somewhat longer than your film. Time the portion of the record you intend to use, and compare it to the screen time of your film. Use a stop watch.

2. Rewind side "A" of the cassette, and record the music.

3. Stop the recorder on the last note of the music. Remove the cassette carefully.

4. With a felt-tip pen, mark a dot on the tape where it is in

*The instructions in this chapter are based on a cassette running speed of 1 7/8 inches per second. Reel-to-reel tape recorders are usually provided with speeds of 3 3/4 inches per second and 7 1/2 inches per second. See footage ratio scale in Appendix H.

contact with the cassette pressure pad. Next to the dot mark the letter "T," for "tail."

5. Set up the projector with the first frame of the picture in the film gate.

6. Making sure that the "T" mark is still directly over the felt pressure pad in the cassette, turn the cassette over, so that "B" side is in its playing position.

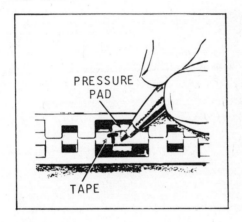

7. At exactly the same instant, start the projector and the recorder. (Use the PLAY button on the recorder, and make sure the projector is running at its proper speed of 18 frames per second.)

8. Stand by, and two seconds after the last frame of picture flashes on the screen, stop the *tape recorder*. (You might have to rehearse this action a few times.)

9. Remove the cassette from the recorder, and place a dot just over the pressure pad. Next to this dot mark the letter "X." The distance from "X" to "T" is now equal to the film length (plus a little more than the two seconds you allowed in Step 8).

10. Return the cassette to the recorder with "A" side in playing position. Make sure that dot "X" is in position over the pressure pad.

11. Rewind the film, and place the first frame of picture in the film gate.

12. Start the tape (using the PLAY button) and the projector at exactly the same instant. This is a test. Picture and sound should start together and end together . . . within a reasonable tolerance of a few seconds. If the sound ends too soon relative to the picture, advance the mark "X" 1 7/8 inches for each second you wish to add to the end. If the sound runs too long, reverse this procedure. You should, however, have one to two seconds of sound overlap at the tail end of the film to allow for future variations in projector speed.

13. Rewind the projector and remove the film. At a point exactly six inches before the first frame of picture, toward the film head, make the mark "X." This is a permanent start mark and will be used each time you show the film with its accompanying sound track.

14. Rewind the cassette and remove it. With a toothpick, reach under the exposed tape to release it, and pull it out about a foot. Stretch the loose tape out on a clean surface, and locate the mark "X." From this mark, measure carefully toward the head of the tape, a distance of 3 3/4 inches. Mark a dot at this point. Next to the dot print a small "H" for "head." This dot will be your starting point whenever you use the tape as an accompaniment for your film.

You now have a film with an accompanying "wild" sound track, which is timed to fit its length. However, there is still a problem to be solved. You will notice that unless you've been very lucky, the music probably starts abruptly. A much more pleasing and professional effect would be created if the music were to fade up at the start or slightly before the start of the film. Here's how to accomplish this:

1. Find the *exact* place on the disc or recording from which you began your sound track that corresponds precisely to the music at mark "H" on your tape.

2. After making sure that the dot marked "H" is over the pressure plate, place the cassette in the recorder, with the "A" side in playing position.

3. You are now going to rerecord the entire sound track. Turn the tape recorder volume all the way down. Start the tape (RECORD mode) and the record player at the same time. The record must be started (cued) from the position located in step #1. Start fading up the sound immediately by turning the volume (gain) control on the tape recorder. You should practice this procedure ahead of time, so that it will take about three or four seconds to reach the proper predetermined recording volume.

If this procedure has been followed carefully, the new recording should coincide almost perfectly with the old. The second recording take should end very close to the "T" mark. You now have a film with a "wild" track which fades up at the start and ends when the film ends.

This same method of sound transfer and timing can be used to score individual sequences, as well as entire films. It is feasible, in fact desirable, in most cases to use more than one piece of music to score films which run longer than ten minutes or so. Great care must be taken to ensure that the music is related to the mood or tensions of the scene and that it is also compatible with the music that precedes it and/or follows it. The choice of a repetitive theme, which returns from time to time, cueing certain characters or actions, is extremely useful. For example, if an important element in your film is a man on horseback riding across the fields, and if in the course of the film he returns three or four times or more, a theme might be developed for him. Under certain dramatic circumstances, once the "man-on-horseback theme" has been well established, you can even anticipate his appearance by cueing his theme a few seconds early.

A "dominant theme" is a piece of music used to open and close your film. It should be used as the basic musical motif, all other music in the film either fading into it or out of it. It's what your audience will be humming after the room lights have come up.

Separate musical themes should begin and end naturally, at normal pauses, or at the start or finish of musical phrases. Where this isn't possible, a sound fade-in or fade-out becomes necessary.

When you are scoring individual scenes, the same procedure as described earlier is used. After you have chosen and timed the music, transfer the sound for each scene individually. Except for the first scene, the procedure described in #13 and #14 is not used. This is a method whereby a cue mark on film and sound track is used in advance of the first scene. For all scenes subsequent to the first one, the scene length is matched on the tape by the distance between "X" and "T" as described in #9. There should still be a few seconds' overlap after the last scene, however, to allow for fluctuation in projector speed.

Naturally, these results will not be synchronized, so a certain amount of overlap, which will probably vary from showing to showing, is bound to occur. For this reason, stay loose. Cutting music on the beat, or using "stingers" or precise musical effects will not be possible. The score will not play quite the same way twice in relation to the picture. There will always be a few seconds discrepancy—something you have to expect with a wild track. Nevertheless, it can be quite effective.

The use of sound effects is also possible, though you are limited to broad unsynchronized sounds, such as racing cars, surf, traffic noises, cheering crowds, etc. Sound effects are cut into a wild sound track either by use of the above method or with techniques described farther on.

Narration

An unsynchronized narration is another possibility. The



narrative should be written after you have first seen the film several times and timed it scene by scene. Your script should indicate scene lengths and specific cues. After your script is prepared, run through it a few times while watching the film.

Remember you are not dealing with precise sound-picture sync, so you have to allow a few beats at the beginning and end of each important scene change, in case of possible future fluctuations in projection speed.

Get your film and tape cued up, sit back comfortably with your eyes on the screen, take a deep breath . . . and record. Don't try to do it all at once. Wherever there is a natural pause in the narrative, stop, and go back, and listen to and watch the previous segments before you continue.

Much can be written about microphone technique, but briefly:

1. Use your own vocal style. Unless you are a professional, an attempt to simulate the style and mannerisms of Howard K. Smith or Walter Cronkite will end in disaster. If you have an accent or a regional dialect, leave it alone.

2. For an intimate, confidential style, keep the mike close and speak "soft and slow."

3. For an authoritative, commanding delivery, keep the mike approximately two feet away, and speak in a moderately loud, forceful manner.

4. Try to avoid a singsong delivery. Don't drop your voice at the end of every phase.

5. Watch out for paper rustlings when turning script pages.

6. Relax and breath naturally, but not into the mike.

It is quite possible to combine two sound tracks: two music tracks can be combined, providing for musical cross-fades, or a music and narration track can be combined along with general sound effects. (This technique will be discussed in more detail a little farther on.)

Postrecording on Film

This is possible through the use of a system based on sound striping. Sound striping is a method whereby a magnetic metallic-oxide stripe, similar to that used on recording tape, is placed along the edge of the processed film* (see illustration on page 37).

Sound-striped film is designed to be played through the sound head of an S-8 sound projector. Most S-8 sound projectors are also capable of *recording* sound from a microphone and/or audio devices such as radios, phonographs, or tape players. Inputs are usually provided for all these devices.

Sound can be recorded directly onto the edited, sound-striped film, or it can be transferred from a preedited tape recording, made separately. The film should be projected during the recording process. You can erase mistakes simply by rerecording over them, as with any tape recorder.

When you are recording a music track, it is usually more efficient to make the original "wild" track on a separate recorder as described earlier, and then transfer it to the striped film, via the tape input jacks of the projector. This method permits a greater amount of control as the entire taped track can be shifted one way or the other. The tape recorder can be stopped and started, in order to take up time slack. Additional control is provided by the use of the gain control on the projector to create fades.

Narration can be recorded with either method, although it is fairly simple to control when you are recording directly onto the film via the projector. Make sure that the narrator is removed as far as possible from the projector when recording, in order to minimize the projector-noise pickup (mike-input extension cords

*Sound striping is a service available from most large photo dealers. It is also provided by Bell & Howell, Synchronex, and others as an adjunct to their film-synchronization systems. There are also sound-striping kits available at moderate cost which enable cinephotographers to stripe their own footage. It is advantageous for technical and economic reasons to sound-stripe your films *after* they are edited.

are available from your local hi-fi shop). When shopping for a projector, steer clear of excessively noisy machines; there are plenty of them on the market.

Postsynchronization

Postsynchronization is possible through the use of an S-8 sound projector. Postsync, if done well, creates the impression that the sound was recorded live, during the filming. It is a method used quite extensively in professional film-making, particularly when conditions on location are unfavorable for sound recording. It is quite effective, though the process is tedious and time consuming.

It is important to start your postsync planning before you shoot a foot of film. Even though the characters are not being recorded during the actual filming, they must *appear* to be speaking, so that the postsync recording will match their lips. Therefore, a dialogue script is important, as it will also be used later during the dubbing session. If your film is ad lib, or a documentary, use a small tape recorder to catch as much of the dialogue as possible, and while you're at it, record some background sound for a second track. A script can later be prepared from this tape for your dubbers to work from.

After your film is cut, edited, and sound striped, assemble your dubbers, one for each speaking character in the film. Assign the parts, making sure to match as well as possible each film character with a voice that is compatible. Have the dubbers read the script and watch the film a few times to get an idea of the timing.

The recording should be made in small segments of no more than one minute each. This dispenses with the necessity for each character to memorize his entire script and permits constant checking of results by the playing back of the film and sound after each segment. Memorizing short sentences instead of reading does away with the danger of script-rattling noises.

The cast should be gathered close together in front of the screen. If only one microphone is used, it should be placed or clamped on a stand. The cast should huddle in close to the mike, feet firmly planted on the floor during recording. As each segment is projected, the individual dubber should speak his lines, watching closely the lips of his corresponding film character (this will be a lot easier for all concerned if the film character and the dubber are the same person).

After a segment (of less than one minute) has been dubbed, reverse the projector to the beginning of the segment, and review the results. If they are not correct, try again; you'll hit it on the head eventually. From time to time, review all the segments to see if they match each other in mood and timbre.

You can also synchronize sound effects, using the same general approach as with speech.

Chapter 17

MULTITRACK RECORDING

Multitrack Recording

 IT is quite simple, actually, to combine sound effects, music, narration, and/or lip-sync speech onto one sound track. If each of the individual tracks is prepared in advance, there are sound studios in most cities of any size which will "mix" them onto quarter-inch tape (combine them onto one tape, complete with proper audio levels for each track, and necessary fades, etc.). However, if you are the proud owner of a stereo tape deck which permits individual recording on left and right tracks (reel to reel or cassette)* or an S-8 projector with mixing facilities, you can do your own multitrack sound recording at almost zero cost as compared to the high fees charged by professional sound studios.

 Here's how to mix a two-channel sound track, using a stereo tape deck or recorder with individual left and right track recording capabilities.

 First edit your film.

 Using methods described earlier, record the narrative on the left track of the stereo tape.

 Then, record the musical score as described earlier on the right track of the stereo tape, while monitoring the left track. This will enable you to cut or fade music down during narrative

*As of this writing the Panasonic RQ 229S recorder is the only cassette recorder available with sound-on-sound or sound-over-sound capabilities.

speeches, and up again between speeches (using the gain controls on the recorder).

If your recorder does not have individual monitoring facilities, use a stop watch to prepare a cueing script. Your script should tell you when to cut or fade your music track.

After the mix is completed, you can, if you wish, transfer it to sound-striped film via a Super-8 sound projector. If your projector has only a single-tape input, place the recorder playback mode on MONAURAL, or use a "Y" adapter to feed both stereo tracks onto the film's single track.

This method can also be used to mix two tracks of music while you are cross-fading one into the other, as desired. Narrative and sound effects can then be added on those portions of either left or right tracks which are silent. A tricky procedure, but possible, because while the left track is producing music, the right track is unrecorded (and vice versa) and can therefore be used to carry narration and sound effects. It calls for fancy timing, as narration has to be switched from track to track.

Sound-Projector Mixing

Some S-8 sound projectors have built-in mixing facilities. This is a highly desirable feature, worth a few extra bucks, as it provides a means of combining or blending two separate sound tracks onto the film striping from any combination of sound sources.

Some of these machines, such as the Bolex, the Eumig, the Bell & Howell Filmsound 488, the Fujica, and others, provide automatic or semiautomatic attenuation during the mixing process. In simpler terms, if you have a music track, for example, which is to be played under a voice track, follow this procedure:

Record the music track first. Then, after rewinding the film to its start mark, record the voice (narration, postdubbing, or whatever). This is where the magic occurs—the music is automatically faded to a predetermined level every time the voice

is recorded over it. On playback, you will notice that as the spoken section starts, the music level drops or fades until the end of the speech and then, a second later, fades up to its previous level. The degree of attenuation on most of these projectors is controllable. In other words, the balance of music-to-speech volume can be predetermined. The example above relates to music and speech, but any two sound sources can be mixed with the same effect.

Therefore, when you are using an S-8 sound projector with autoattenuation, the background or music track should always be recorded or transferred onto the sound striping first, before the primary or voice track.

Or, to put it another way, when dubbing dialogue or recording narration, etc., make sure your edited sound-striped film has already been scored with music and/or sound effects; otherwise, it will be the voice or the primary track which fades up and down, rather than the background effects.

If you are fortunate enough to have an S-8 sound-mixing projector *plus* a stereo tape recorder or deck equipped with individual right and left track input controls, you can mix three tracks instead of the usual two. This of course opens up a whole new world of possibilities:

1. After editing the film, use your stereo recorder to record music on the left track of side "A."

2. Record additional music and/or other effects on the right track of side "A," while monitoring the results.

3. Transfer the right and left side of the side "A" stereo tape to the film sound-striping via the projector tape-input. Make sure the playback mode of the tape recorder is on MONAURAL, or use a "Y" connector to combine both stereo tracks into a single output.

4. Record post-lip-sync (dubbed sync) or narration directly onto the sound striping via the projector microphone. The previously recorded two-track background material will automatically be attenuated, or faded down, each time the voice is recorded over it. The results can be beautiful.

Chapter 18

SYNCHRONIZATION

SYNCHRONIZATION

"**S**YN'CHRO-NIZE (nīz)-v.t. (Gr. *synchronizein*)
Motion Pictures. To add (sound effects or dialogue) in time and
harmony with the action of a picture; to add such effects to a
picture."— *Webster's.*

Sound recording for S-8 filming is now coming of age. Lip
synchronization is now practical. However, because of the basic
limitations placed on S-8 cinema-photography, certain sim-
plifications are necessary. These basic limitations include the
lack of professional editing and mixing equipment, of access to
sound stages, and of true high-fidelity recording equipment.
Nevertheless, it is possible to make full-length, edited motion
pictures, including multiple-sound-track synchronized sound-
recording, with existing S-8 equipment.

Professional motion-picture production represents an
amalgam of many specializations: writing, photography,
direction, lighting, makeup, art direction, editing and sound—
all complex specialties performed by talented individuals, often
with large staffs to aid them. The beginning movie maker,
however, has to do it all himself, or with a little help from his
friends.

The problems associated with sound recording on location,
which professionally is an art unto itself, can be the straw that
breaks the film maker's back. He not only must concern himself
with light, action, composition, and timing, but now, the added

172

dimension of sound and its associated concerns: dialogue, synchronization, mike placement, background noises, etc. Nevertheless, with it all, excellent S-8 sound films are produced.

The beginning film maker should be sparing in his use of sync-sound on location. This means one thing: *dialogue should be used only when necessary.* In life, people do not talk constantly; there is little reason why they should in your films. Music and sound effects can fill the silent gaps.

There are two basic types of sound-synchronized camera systems: single-system sound and double-system sound. The basic function of each of them is to record a synchronized sound track during the actual filming process. When played back, film and sound will be in perfect synchronization, each with the other. Truly a magnificent accomplishment.

Single-System Sound Recording

Single-system sound recording records sound directly on the film in the camera, simultaneously with picture. The film is sound striped. No tape recorder or other recording device is needed, and synchronization is not dependent on the use of electronic circuitry, but is maintained by purely mechanical means. When the exposed film is returned from the processing lab the sound and the picture are in synchronization. Single system is perfect, therefore, for spot news coverage, where speed is of the essence. Other than that, its use is restricted, as extensive editing is all but impossible. On S-8 film, sound precedes picture by 18 frames. This is necessary in order to dampen or smooth out the intermittent movement of the film as it passes, a frame at a time, through the film gate of the camera or projector.* Therefore, when a single-system sound film is edited, each cut made in the film loses almost a second, or 18 frames of

*Each frame of film in turn must be momentarily stationary while being projected. The 18-frame lead is necessary in order to dampen out the intermittent action occurring at the film gate so that film will move smoothly over camera and/or projector sound heads.

sound. Some editing is possible, however, if the cuts are made during natural pauses in the dialogue. But difficulty will arise if more than that is attempted. Obviously, with single system every time you cut the picture, you also cut the sound. Therefore, it is almost impossible to accomplish a sound track that is continuous through film cuts, and sound mixing is all but impossible with single system. Editing out of shooting sequence becomes a real problem, particularly when cut-aways are used. Nevertheless, as a beginner's tool, or for home movies and vacation films (in addition to spot news coverage), single system is adequate and convenient.

Single-system sound recording can be built into Single-8, Standard-8, and Double-Super-8 cameras. At the moment, however, single-system sound can be found only on the now discontinued Fairchild Standard-8 sound camera (used models of the Fairchild can still be found and purchased at reasonable prices). It is probable that sooner or later there will be new S-8 versions of this system—Single-8 or Double S-8, but *not* Super-8. A true single system would be impossible to design into the Super-8. To record sound on film in the camera, we must have the 18-frame sound lead. Because of its built-in pressure plate, the Super-8 cartridge has only a few frames available outside the cartridge, and there is no way to feed out the required 18 frames.

There is, however, a kind of *semi*-single system available in the Super-8 format: the "Synchronex," a packaged Super-8 sound system which requires its film processing to be done by the manufacturer. Synchronex, because of the Super-8 cartridge limitations, requires the use of its own separate sync-pulse cassette-type recorder. After filming and recording, both tape cassette and film cartridge are sent via air mailer to the Synchronex laboratories for processing, and the sound is transferred to the film. What is returned by post is essentially single-system sound on film. The now erased tape cassette is also returned and may be reused. The Synchronex system is inexpensive to purchase, but film costs are high because of its 24-frame-per-second

"normal" running speed, which eats up film rapidly (normal playback must be at 24 fps also).

Double-System Sound Recording

Practically all professional motion pictures are made with double-system sound synchronization. In most cases, the sound is recorded on location during the filming. Exceptions usually involve dubbed or postsync recording, which actually is another form of double-system recording.

Unlike single system, double system does not involve recording originally on a striped or optical sound track. The word "double" refers to the use of a tape recorder placed in synchronization with the camera. Both camera and tape recorder run simultaneously during the filming process. The result is a film and a tape, separate from each other, but containing all the information needed to place them in synchronization.

The double-system sync camera generates an electrical pulse as each frame of film passes through its gate, one pulse for each frame. The pulses are transferred via an "umbilical" to the tape recorder, which records them onto one track of a dual-track tape. The tape is thus encoded with audio pulses, each one corresponding to an individual frame of film. When the tape is played back, these audio pulses govern the speed of the projector (the tape player is connected to the projector, and each pulse on the tape effectively advances the projector one frame).

Film and tape must be *edited together,* after which the edited film and tape can be played back in perfect synchronization, with the tape recorder and projector connected electrically and operating in tandem. Or the edited tape can be transferred in sync onto the sound-striped edge of the correspondingly edited film and played back as a single unit.

The main advantage of double-system sound is the complete flexibility it affords in the editing process.

Many S-8 cameras available today have sound-pulse capability

built in for future use when compatible recording equipment is developed. However, there are currently a few high-quality complete double systems available.

One of the most professional of these is the Optasound System (available through Optasound Corporation, 116 John Street, New York, New York 10038). Optasound will, for a fee, modify almost any S-8 camera to their unique pulse system. Once this is accomplished, the film maker can avail himself of some of Optasound's truly sophisticated components for recording and editing S-8 sound.

A necessary component for the Optasound system is "Optasync," a diminutive 13-ounce solid-state device, which provides lip-sync sound when connected between any electrically driven camera and any reel-to-reel tape recorder. To use the camera without sound (MOS) one simply disconnects it from the recorder.

For editing and playback there is "Edi-Sync," a sprocket-driven tape deck which interlocks mechanically with any S-8 sound or silent projector. It provides foolproof sound transfer to film striping, retaining full lip sync. It is also capable of full synchronous playback without the use of magnetic striping. Edi-Sync is an (almost) complete tool for synchronous editing.

The Optasound system requires the use of reel-to-reel tape recorder, using sprocketed quarter-inch tape, purchased through the Optasound company. The essence of the system is the sprocket-tape drive, which ensures absolute synchronization through the ingenious expedient of using the actual sprocket holes on the tape to generate the projector sync-pulse. Since the film sprockets and the tape sprockets are matched, one to a frame, there is no need to implant a pulse signal on the tape. Editing is, of course, greatly simplified because of this. The Optasync system is by far the most professional S-8 sound system currently available.

The Bell & Howell Filmsound-8 system consists of camera, projector, and tape recorder. Bell & Howell manufactures all

three of these major components, and Canon also makes a few superb cameras which are compatible.

The system works through the means of an electrical pulse transmitted via umbilical from camera to tape recorder. With the recorder running, sound is recorded on the "A" track, while the pulse is recorded on the "B" track of the tape cassette, one pulse for each frame of film. During playback, the recorded tape-pulses control the projector speed, frame by frame, and synchronization is achieved.

Each time the camera is started, 15 to 25 frames of film move through the film gate to allow for a sync cushion. At that point, a cue lamp flashes in the camera, exposing a two-frame start signal on the film edge, and at the same instant the camera cues a start signal in the tape recorder. Tape recorder and camera then run in synchronization with each other, until the camera trigger or run button is released, at which time the recorder generates a

A-B

STOP
PULSE →

stop signal. This stop signal halts the recorder action and also implants a signal on the tape.

To play back the processed film and tape in synchronization, a Bell & Howell Filmsound projector is required. The tape recorder for playback is the same Filmsound tape recorder used during the filming process. When the projector is started, it runs through some leader, then through 15 to 25 frames of "cushion," before the "start" mark or signal (exposed onto the film edge during the filming process) passes through the projector film gate.

This start mark is now in the form of a clear area two frames long on the black edge of the film. As the film moves through the projector, a photoelectric cell detects the clear area and trans-

mits a signal to the tape recorder, which starts rolling. With picture and sound running, the prerecorded sync-pulses on the "B" track (or side) of the tape control the speed of the projector, locking it into synchronization with the tape player, frame by frame. At the point where the "stop" mark (recorded on the tape during filming) passes over the recorder heads, the tape stops abruptly. This is the end of a scene. The projector keeps rolling, however, through a 15- to 25-frame "cushion" (which is automatically instituted at the start of every scene), until another start mark passes through the film gate, recycling the entire procedure once again. The 15 to 25 frames of "cushion" may later be edited out of the film without affecting synchronization.

Bell & Howell supply tape cassettes which are especially made for the system. They come in both 4-minute and 30-minute sizes. The 4-minute length is compatible with one 50-foot film cartridge (at standard 18 fps); the 30-minute length is good for seven such cartridges. High-quality tape cassettes packaged by other manufacturers are compatible with the Filmsound system, if you adapt them by removing just enough leader from the head of the tape to position oxide tape over the pressure pad (most commercial tape cassettes have long leaders which must run a few seconds before the actual tape is exposed). This should only be done, however, on those rare occasions in Timbuktu or other obscure locations where Bell & Howell cassettes are not available. Cassette adaptation at best is a questionable economic saving. Beware also of bargain tapes.

The Filmsound tape recorder has an output for an external speaker, which of course would represent an improvement in sound quality over its small built-in speaker. An even greater improvement in quality can be accomplished if you equip the tape recorder so that it can play through the circuitry of your hi-fi amplifier. Any competent radio repair shop can, for a small fee, supply the proper patch cord and attenuating network for this purpose.

Bell & Howell, through its dealers, will transfer the edited cassette tapes to sound-striping in sync.

Chapter 19

RECORDING TECHNIQUES

A MICROPHONE, unlike the human ear, is totally unselective. The ear will eventually adapt itself to background noise; the microphone makes no such discrimination. Try an experiment; wherever you are at this moment, stop and *listen*. Concentrate carefully on all the sounds that you've managed to tune out. There might be a refrigerator cycling, a radio from the next house or apartment, the sound of the wind, traffic, the dim undertones of conversation from nowhere, an airplane in the distance, the clatter of dishes from the kitchen. . . . We should all probably go mad without the ear's ability to discriminate and listen selectively. A tape recorder, however, connected to a microphone, is devoid of discrimination. Selectivity is purely a function of the individual making the recording.

Selectivity is controlled in great part by mike placement. Mike sensitivity is related to the square of the distance. Cut the distance between the microphone and the subject in half, and the mike will be four times more sensitive to the subject. This means that if you move the mike closer to the main sound source, the gain (volume) can be cut considerably—in many cases, low enough so that background noises will be unrecorded.

One of the most critical sources of aberrant sound is the

camera itself. Professional cameras are often "blimped" or encased in a soundproofed housing in order to overcome this problem, but there is currently no such equipment for the S-8 film maker. Therefore, it is necessary to place the mike as far from the camera and as near to the subjects as possible.

The major area of mike sensitivity (for most microphones) is a cone-shaped area extending from the front. The angle of the cone is determined by the type of microphone. Generally speaking, most mikes made for inexpensive recording equipment are almost omnidirectional, with fairly wide cones. Nevertheless, it is well to keep in mind that the area of least sensitivity will always lie to the rear of the microphone. It is therefore always expedient to point the mike *away* from the camera.

Listed below are some ideas for mike placement and control. As a listing, it is far from complete, but all the basics are present. A little imagination on the part of the reader could very easily double the number of ideas.

1. *Mike Boom*. A mike boom can be constructed from an old fishing rod and a light stand. Clamp the fishing rod to the stand, and tie the mike to the end of the fishing line. A spinning or casting reel can be used to lower or raise the mike. If an assistant is available, the light stand can be dispensed with. The assistant can stand on a ladder or a chair as he directs the boom to follow the action. A light boom is ideal to get the mike in close to the subjects from overhead and still remain just out of camera range.

2. *Lavalier Microphones*. This is a mike that is worn by the subject, usually around the neck. Such an arrangement can be rigged with almost any omnidirectional microphone, even the one you got with your tape recorder. The problem here is that only the person wearing the microphone will be picked up adequately. (See section on mike mixing below.)

3. *Hidden Microphones*. Mikes can be hidden in flower pots, breast pockets, behind books, in chandeliers, under magazines,

Interviews are best shot in locales indicative of the subject. The mike in this case could be hidden behind the column.

in ashtrays, you name it. The main criteria are that the mike be close enough to the subjects and pointed the right way. You're not bugging the premises, you're just making a film, so the only object is to conceal the mike and its cable from the camera. Microphone cable can be taped along baseboards, hidden under rugs, etc.

4. *Telephoto Microphones.* One type is called a "shotgun" mike, and it is very expensive, probably even more costly than your entire rig. However, there is another type of microphone assembly generally overlooked by film makers: the sound parabola. This is a device shaped like a radar dish that picks up sound pretty much the way a long telephoto lens perceives picture. It's great for nature photography, and documentary or *cinéma vérité* films, as it not only does much to kill aberrant background and camera noise, it can also pick up distant dialogue. Sound parabolas are available from Bell & Howell, 7100 McCormick Road, Chicago, Illinois 60645; Lafayette

Radio, 111 Jericho Turnpike, Syosset, Long Island, New York 11791; and Dan Gibson, 196 Bloor Street, West, Toronto 5, Canada.

5. *Interviews, Panels, and Rap Sessions.* Passing a microphone from one person to another is a sure way of creating a disconcerting recorded noise. If you are shooting an interview situation involving more than two or three people, the best compromise is to have the guy in the middle hold the mike. With more than three people, try to find a place where the microphone, attached to a stand, covers all of them. A light stand will do.

6. *Mixing Two or More Microphones.* It is quite possible to use more than one microphone to record a scene. To do this you need a mixer. This is a device with two or more microphone inputs and a single output (stereo mixers have two outputs). Each mike input has a separate gain control, which is adjusted separately for each microphone. The operator monitors the recording through a headset while "riding" the gain on his microphone inputs. The resultant combination is piped to a tape recorder (reel to reel or cassette) as a single signal. With this method, each member of a cast can wear a lavalier, and/or multiple microphone setups can be made for almost any purpose.

Mixers are also useful for the simultaneous mixing of other sound sources in various combinations: narration and music, or narration and sound effects, or sound effects and lip sync, etc.

7. *Wireless Microphones.* Wireless mikes are used professionally when it is not practical to have the mike connected to a camera or a recorder. They are literally tiny radio transmitters and are very expensive. However, a reasonably good walkie-talkie, equipped with a tape output and a small mike (once again, see your local radio repairman), can be used the same way. Naturally, a bulky walkie-talkie cannot be worn unobtrusively by the subject the way a true wireless mike can, but with a little subterfuge, it can be hidden from the camera.

Another solution is the use of wireless intercoms. These are devices which, in order to function, are plugged into a household

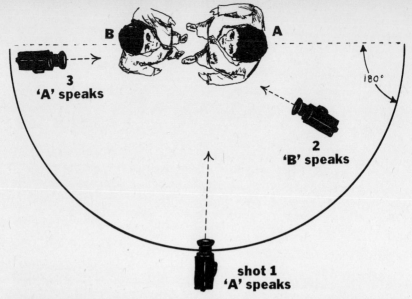

In a series of shots (such as the series above) used to make up a dialogue sequence, the screen position of "A" will remain constant with "B" on the left and "A" on the right. Shooting from the other side of the dotted line would reverse this order, resulting in audience confusion (within a given sequence).

electrical circuit and actually transmit through the electrical wiring. Again, the receiving end must be modified with a tape output.

Neither of these two devices has a sound quality approaching that of a real FM wireless mike, but they work, once you deal with the problems of interference and hum. It's better not to use either of them for anything other than voice transmission. One unit at the receiving end can accommodate any number of transmitting units via a sound mixer. Make sure that all walkie-talkie transmitters operate on the same channel.

Wireless intercoms are handy to use in interior situations in which it is difficult to hide mike wires or in which because of low ceilings a mike boom is impossible to use. Wireless intercoms are as easy to hide as mikes.

Walkie-talkies are useful for situations in which the subjects are moving about constantly. A couple walking through the woods, for example, can transmit their dialogue via a walkie-talkie. To follow them with a hand mike or a boom would be difficult, particularly in wide shots.

Chapter 20

SYNCHRONIZED SOUND-FILM EDITING
(DOUBLE SYSTEM)

THERE are as many different sound-editing procedures for S-8 photography as there are sound-film systems. Nevertheless, there are some general methods which apply to all types and gauges of synchronized sound-film editing.

Cutting Sound to Picture. With this method of cutting, the sound track is "subservient" to picture. The length of the track is determined by the length of picture. A simple example might involve a scene from which you wanted to remove a few seconds of film. In this case, you would first cut the film and then proceed to cut out the corresponding section of tape. In planning this cut, of course, you would have to make sure that the sound cuts occurred during natural pauses, if there was dialogue or some other kind of sound continuity.

Cutting Picture to Sound. This can be a very creative technique. For example, you can lay down a strong rhythmic music track and actually cut the picture to the beat. This is a relatively easy thing to do with 16mm and 35mm professional editing techniques through the use of specialized editing equipment, such as the Moviola, which is capable of isolating sounds and the individual frames of film to which they relate. S-8 film editors, unfortunately, have no such facilities at their disposal as yet.

There is, however, a fluid called Visi-Mag (Magnecessories, Box 6960, Washington, D.C. 20032) generally available in large

audio shops, which makes visible the electronic signal implanted on the tape.

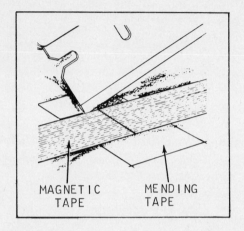

Magnetic tape can be spliced with special pressure-sensitive mending tape. The mending tape must be applied to the side of the magnetic tape that makes contact with the pressure pad of the cassette so that none of the control pulses recorded on the tape are lost. Cut a short strip of mending tape and press one cut end of the magnetic tape to the sticky side. Then carefully press the other cut end of the mending tape so that the two ends are exactly mated. With a razor blade, carefully cut away the splicing tape that extends beyond the edges of the magnetic tape.

When the tape is saturated with Visi-Mag, it becomes quite simple, with a little practice, to locate visually the high points of rhythmic beats in the music. Using the synchronizer (see Appendix page 213), mark the film frames corresponding to the beats on a piece of blank leader of appropriate length. The leader, of course, must first be marked with a start mark common to the tape. After all the necessary beats have been marked, the film is cut to match the marked leader.

The result is a film which cuts from scene to scene on the beat of the music. Of course you probably will not cut on every beat; you can set up a rhythm to cut on every fourth or sixth beat, or on the most prominent beats, or mix it up, for that matter. Experimentation is the best teacher in this department. In-

cidentally, this technique works beautifully with dance films.

When you are cutting a picture into sync footage, the amount of picture being inserted into an assembled film must be exactly equal to the amount that was cut out, another example of cutting picture to sound. For instance, if you have a sequence of two people in conversation walking along a beach, your sync shooting may, for example, be done in five takes (not including retakes for mistakes, etc.). One take would be a medium trucking shot, which would run the full length of the sequence, let's say a minute. The second would be a frontal medium shot, with the subjects approaching the camera, which might run for about 8 seconds. The third could be three closeup pans involving spoken lines from both subjects, running a total of about 5 feet, or 20 seconds. In addition to this sound footage, you would also shoot around 20 feet of assorted wild silent footage of sea gulls in flight, surf, feet slogging through the water's edge, long shots of the couple as they walked, engaged in conversation, from at least two angles, and a long closing zoom-back ending in a fade.

To cut all of this together, the first step would be to lay down a complete assembly consisting of those sync shots you wanted to use. You are covered in terms of a complete sound track of the entire sequence, because you shot and recorded the medium

Common splicing errors.

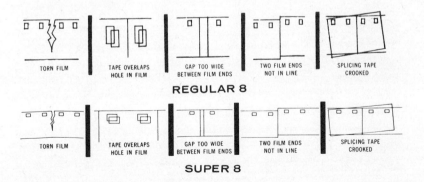

trucking scene from beginning to end. Into this you would lay picture and sound of your closeups and your medium frontal shot. You would treat them as sound and film inserts, using the synchronizer and measuring back to a predetermined cue mark. Once you had a complete continuity, or assembly in sync, it would be a simple matter to make picture inserts of the sea gulls, long shots, etc., just by cutting them into the film assembly as if it were a silent film. For every frame of film you insert, however, you must remove a like amount, this keeps you in sync.

The long shots work as silent takes because they are too far from the camera for the lips to be read. The common sound track runs right through them, tying them in with sync scenes on both sides. The same applies to the cut-aways, the sea gulls, the surf, the feet, etc. The last scene, also inserted, is the long zoom-out. You would measure this scene from its tail end so that the sequence ends with a complete fade-out.

The edited sequence, including cut-aways and long shots (wild, silent footage), will probably consist of less than half of your original sync footage. With experience, you will find it less and less necessary to cover an entire sequence in sync sound as you become more adept at previsualizing the placement of your wild-picture inserts.

Correcting Minor Sync Errors. If for some reason you lose sync along the way, stop, look, and listen, to determine whether it is sound or picture that is ahead. If it is sound, and it seems to be less than a second out of sync, try cutting a few frames of picture at the *head* of the scene which is out of sync. Continue cutting, a few frames at a time, checking the results as you go along until you are back in sync.

On the other hand, if it is picture that is ahead, find a short, silent stretch of tape toward the head of the scene and cut a quarter inch at a time, constantly checking with projector and playback until sync is regained. To repeat: If sound is ahead, cut picture. If picture is ahead, cut sound.

CONCLUSION

Of all the cardinal rules applied to film making, I believe only one has total validity. That is the rule of simplicity. Keep it simple, uncomplicated. Everything you do filmically has to relate to what you are attempting to say or to the mood you are attempting to set. Anything else is superfluous: Scenes shot from odd, distortive angles, for no particular reason. Unnecessary camera movements or zooms. Holding a shot on a blank wall or on another meaningless detail long after the subject has moved out of frame. The excessive use of extreme wide-angle lenses. All these things, when done without real purpose or overdone, can confuse, disturb or mislead your audience into thinking there is significance where there is none.

An outstanding example of tightly oriented cinema photography is John Ford's *The Informer*. When making this magnificent film, Ford even went so far as practically to dispense with the moving camera.

It should be obvious by now that your best classroom is the movie theater. But there are other classrooms. The art gallery is one of them. From painting, you can learn a great deal about composition and color. This is particularly true of impressionistic art, which has influenced a few generations of film makers and photographers. An obvious example of this is *Moulin Rouge*. John Huston's *Moby Dick* is a less obvious example. Akira Kurosawa's *Rashomon* and *Ugetsu* are also examples relating to Japanese graphic art.

189

From the still photographer you can also learn about composition and, just as important, lighting. The still photographer works a frame at a time without the film maker's third dimension of movement. Therefore he has to create visually exciting images consistently in order to achieve success. A knowledge and understanding of the art of still photography can therefore be an asset to the beginning film maker. The goal of producing a film from which one can pick at random any single frame and find a photographic masterpiece has probably never been achieved, but many come close: Carol Reed in *The Third Man*, D. W. Griffith in *Orphans of the Storm*, David Lean in *Ryan's Daughter* or *Lawrence of Arabia*, Stanley Kubrick (an ex-still photographer) in *Paths of Glory*, F. W. Murnau in *The Last Laugh*, Roberto Rossellini in *Paisan*, Elia Kazan in *Viva Zapata* and *America America*, Federico Fellini in *Juliet of the Spirits*. It is obvious that most of the scenes in these films were composed visually in the same manner that a talented still photographer composes his pictures. They all are *visual* works of art.

The motion picture is a medium then that is influenced by other art forms. It is also influenced by the mores and attitudes of its time. A film made today stands as a record, a document for posterity. The posterity I speak of may include only your children and grandchildren, or it may encompass a much larger audience. Good luck.

Appendixes

Appendixes

Appendix A

EXAMPLE OF FILM-SPEED RATINGS AND F-STOP RELATIONSHIPS

ASA	1600	1200	800	600	400	320	200	160	125	100	64	50	32	25
f-STOP	f/*11	f/9.5	f/*8	f/6.3	f/*5.6	f/4.5	f/*4	f/3.5	f/3.2	f/*2.8	f/2.5	f/*2	f/1.7	f/*1.4
			(2X)		(4X)		(8X)			(16X)		(32X)		(64X)

All of the above combinations will have a similar exposure effect on film, as they all are more or less equal. For example, f/8 on ASA 800 rated film will produce the same exposure density as f/2 on ASA 50 rated film.

*Full stops.

APPENDIX B
RUNNING TIME FOR S-8 FILMS

18 fps* Ft. & Frames		Running time†	24 fps Ft. & Frames	
0	18	1 sec.	0	24
0	36	2 sec.	0	48
0	54	3 sec.	1	0
1	0	4 sec.	1	24
1	18	5 sec.	1	48
1	36	6 sec.	2	0
1	54	7 sec.	2	24
2	0	8 sec.	2	48
2	18	9 sec.	3	0
2	36	10 sec.	3	24
5	0	20 sec.	6	48
7	36	30 sec.	10	0
10	0	40 sec.	13	24
12	36	50 sec.	16	48
15	0	1 min.	20	0
30	0	2 min.	40	0
45	0	3 min.	60	0
60	0	4 min.	80	0
75	0	5 min.	100	0
90	0	6 min.	120	0
105	0	7 min.	140	0
120	0	8 min.	160	0
135	0	9 min.	180	0
150	0	10 min.	200	0
450	0	30 min.	600	0
900	0	1 hr.	1200	0

*Frames-per-second filming and projection speed.
†A 50-foot S-8 magazine runs for 3 minutes, 20 seconds at 18 fps, or 2 minutes, 30 seconds at 24 fps.

APPENDIX C
PROJECTION SCREEN RATIOS

SCREEN WIDTH	LENS FOCAL LENGTH	12.7mm (1/2 in.)	19mm (3/4 in.)	25.4mm (1 in.)	32mm (1 1/2 in.)
40 in.		8 ft.	12 ft.	16 ft.	20 ft.
50 in.		10 ft.	15 ft.	20 ft.	25 ft.
60 in.		12 ft.	18 ft.	24 ft.	30 ft.
70 in.	Distance: Projector to Screen	14 ft.	21 ft.	28 ft.	35 ft.
84 in.		17 ft.	25 ft.	33 ft.	42 ft.
8 ft.		19 ft.	28 ft.	38 ft.	48 ft.
9 ft.		21 ft.	32 ft.	43 ft.	54 ft.
10 ft.		24 ft.	35 ft.	47 ft.	60 ft.

APPENDIX D

FILTERS FOR USE WITH BLACK-AND- WHITE FILMS

FILTER No.	COLOR OR NAME	SUGGESTED USES
3	(Aero 1)	Aerial photography, haze penetration.
6	Yellow 1	For all black-and-white films, absorbs excess blue outdoors, thereby darkening sky slightly, emphasizing the clouds.
8	Yellow 2	For all black-and-white films, most accurate tonal correction outdoors. Produces greater contrast in clouds against blue skies, and foliage. Can be used for special effects with color film.
9	Yellow 3	Deep yellow for stronger cloud contrast.
11	Green 1	Ideal outdoor filter where more pleasing flesh tones are desired in portraits against the sky than can be obtained with yellow filter. Also renders beautiful black-and-white photos of landscapes, flowers, blossoms, and natural sky appearance.
12	Yellow	"Minus blue" cuts haze in aerial work, excess blue of full moon in astrophotography.
13	Green 2	For male portraits in tungsten light, renders flesh tones deep, swarthy. Lightens foliage.
15	Deep Yellow	Renders dramatic dark skies, marine scenes; aerial photography. Contrast in copying.
16	Orange	Deeper than #15.
21	Orange	Absorbs blues and blue greens. Renders blue tones darker such as marine scenes.
23A	Light Red	Contrast effects, darkens sky and water, architectural photography. Not recommended for flesh tones.

25A	Red 1	Use to create dramatic sky effects, simulated "moonlight" scenes in midday (by slight underexposure). Excellent copying filter for blueprints. Use with infrared film for extreme contrast in sky, turns foliage white, cuts through fog, haze, and mist. Used in scientific photography.
47	Dark Blue	Accentuates haze and fog.
47B	Dark Blue	Lightens same color for detail.
56	Light Green	Darkens sky; good flesh tones.
58	Dark Green	Contrast effects in microscopy; produces very light foliage.
61	Dark Green	Extreme lightening of foliage.
64	Green	Absorbs red.
Neutral Density	All Film Types Color or Black and White	For uniform reduction of light with high-speed films for still and movie cameras. No change of color value.
Polarizer	All Film Types Color or Black and White	Eliminates surface reflections, unwanted glare, or hot spots from any light source. The only filter that will darken a blue sky and increase color saturation.

Courtesy: Tiffen Optical Company.

APPENDIX E

FILTERS FOR USE WITH COLOR FILM

FILTER No.	SUGGESTED USES
CLEAR	Optical glass lens protection with no color shift.
SKY 1A	Use at all times, outdoors, to reduce blue and add warmth to scene. Also in open shade.
HAZE 1	Reduce excess blue caused by haze and ultraviolet rays. Ideal for mountain, aerial, and marine scenes.
HAZE 2A	Greater ultraviolet correction than Haze #1 filter; adds some warmth to the visible colors.
UV15	Haze filter.
UV16	Reduces excessive blue in electronic flash; also may be used for haze correction.
UV17	Greater haze correction; reduces blue in shade.
81	Yellowish, warming filter.
81B	Warmer results than with 81A.
82	For any 100° increase in Kelvin temperature for color renderings.
82A	With daylight films use in early a.m. or late p.m. to reduce the excessive red of the light. When using Type A (3,400°K) films under 3,200°K lamps.
82B	For cooler results.
82C	For cooler results or when using 3,200°K lamps.
85	Converts Type A film to daylight.
85B	Converts Type B film to daylight.
85C	Helps prevent overexposure of blue record layer.

CC30R	For underwater photography, to correct color. Also, to compensate for distortion of color when shooting through transparent plastic windows similar to vistadomes provided by railroads for camera fans.
FLB	Eliminates the deep blue-green cast ordinarily resultant from shooting color films with fluorescent lights.
FLD	FLB Type B films FLD Daylight films.
Neutral Density	For uniform reduction of light with high-speed films for still and movie cameras. No change of color value.
Polarizer	Eliminates surface reflections, unwanted glare, or hot spots from any light source. The only filter that will darken a blue sky and increase color saturation.

Courtesy: Tiffen Optical Company.

APPENDIX F

COMBINATION FILTERS

FILTER NO.	SUGGESTED USES
3N5	Combines #3 with 0.5 neutral density.
8N5	Combines #8 with 0.5 neutral density, for control of high-speed films with same applications of #8 (yellow 2) filter.
85N3	85 combined with ND 0.3. Converts Type A film to daylight. Permits use of larger lens apertures.
85N4	85 combined with ND 0.4. Converts Type A film to daylight. Permits use of larger lens apertures.
85N6	85 combined with ND 0.6. Converts Type A film to daylight. Permits use of larger lens apertures.
85N9	85 combined with ND 0.9. Converts Type A film to daylight. Permits use of larger lens apertures.
85N1.0	85 combined with ND 1.0. Converts Type A film to daylight. Permits use of larger lens apertures.
85POL	85 combined with Polarizer. Converts Type A film to daylight with all advantages of polarizer.
23A + 56	Creates night effects in daylight, with pan film only.

NEUTRAL-DENSITY FILTERS

Tiffen Type	Density	% Light Transmission	Increase in Stop
ND .1	0.10	80	1/2
ND .2	0.20	63	3/4
ND .3	0.30	50	1
ND .4	0.40	40	1 1/4
ND .5	0.50	32	1 3/4
ND .6	0.60	25	2
ND .7	0.70	20	2 1/4
ND .8	0.80	16	2 3/4
ND .9	0.90	13	3
ND 1.0	1.00	10	3 1/4

Neutral-density filters to ND 4.0 on special order.
Courtesy: Tiffen Optical Company.

APPENDIX G EXPOSURE-COMPENSATION GUIDE FOR S-8 CAMERAS
For ASA-25 (40), unless otherwise indicated.

SITUATION	f-stop (approx.) @ 18 fps	COMPENSATION FOR AUTOMETER	NOTES
NIGHT SCENES People and other subjects, lit by typical "downtown"-type neon lights, electric signs, etc.	f/1.4 or f/2		Exposure suggested for ASA 80 to 160 film. Use tungsten film or deactivate conversion filter.
NIGHT SCENICS "Downtown." Electric lights and neon signs in picture.	f/2.8		Use tungsten film or deactivate conversion filter.
BEACH SCENE Front light, bright sun. *Medium shot.*		Increase exposure 1/2 stop.	Alternative: closeup reading.*
BEACH SCENE Front light, bright sun. *Long shot.*†		Increase exposure 1 stop.	Alternative: closeup reading.*
BEACH SCENE Backlight, bright sun. *Medium shot.*		Increase exposure 1 stop.	Alternative: closeup reading.*
BEACH SCENE Backlight, bright sun. *Long shot.*†		Increase exposure 1 1/2 stops.	Alternative: closeup reading.*

SNOW OR GLARE-ICE Front or overhead light. Bright sun. *Medium shot.*		Increase exposure 1 stop.		Alternative: closeup reading.*
SNOW OR GLARE-ICE Front or overhead light. Bright sun. *Long shot.†*		Increase exposure 1 1/2 stops.		Alternative: closeup reading.*
SNOW OR GLARE-ICE Backlight. Bright sun. *Medium shot.*		Increase exposure 1 stop.		Alternative: closeup reading.*
SNOW OR GLARE-ICE Backlight. Bright light. *Long shot.†*		Increase exposure 2 stops.		Alternative: closeup reading.*
LARGE BODY OF WATER Backlight. Bright sun.†		Increase exposure 1/2 to 2 stops.		Exposure increase depends on the amount of spectral reflec- tion in the water which might affect built-in light meters. Late-afternoon reflec- tions would probably call for 1 1/2 stop increase.
AVERAGE SUBJECT Backlight. Bright sun. *Medium shot.*		Increase exposure 1/2 stop.		Alternative: closeup reading.*

Appendix G (Continued)

SITUATION	f-stop (approx.) @ 18 fps	COMPENSATION FOR AUTOMETER	NOTES
AVERAGE SUBJECT Backlight. Bright sun. *Long shot.*†		Increase exposure 1 stop.	Alternative: closeup reading.*
AVERAGE SUBJECT AGAINST DARK BACKGROUND Medium shot.		Decrease exposure 1/2 to 1 stop.	Alternative: closeup reading.*
AVERAGE SUBJECT AGAINST DARK BACKGROUND Long shot.		Decrease exposure 1/2 to 2 stops.	Alternative: closeup reading.* Exposure decrease depends on degree of background darkness.
AVERAGE SUBJECT AGAINST WHITE BACKGROUND Medium shot.		Increase exposure 1/2 stop.	Alternative: closeup reading.*
AVERAGE SUBJECT AGAINST WHITE BACKGROUND Long shot.		Increase exposure 1 stop.	Alternative: closeup reading.*

SPOTLIGHTED THEATRICAL PERFORMERS Medium shot.	f/2.8 or f/4	Decrease exposure 1/2 to 1 stop.	Use tungsten type film or deactivate conversion filter.
SPOTLIGHTED PERFORMERS Long shot.	f/2.8 or f/4		Use tungsten film or deactivate conversion filter.
RINGLING BROS. CIRCUS, ICE HOCKEY, BASKETBALL, AND OTHER ARENA-TYPE ACTIVITIES IN MOST CITIES	f/2 or f/2.8		Use tungsten film or deactivate conversion filter
SCENICS FROM AIRCRAFT Bright sunlight or light overcast.		Stop down 1 stop.	Use UV filter. If windows are tinted, use Tiffen 30R or equivalent.

*When you are taking closeup readings subject should fill over 1/2 frame.

†Exposure increases apply only to subject lighting. A smaller increase or no increase at all will result in some degree of silhouette. (This may sometimes be desirable for dramatic effect.)

With no subject in the scene (landscape) the recommended increase should be halved. With backlit subjects the autoexposure (with no increase) will sometimes enhance visual drama, and a decrease in exposure of from 1/2 to 1 full stop will result in simulated nighttime.

APPENDIX H

FOOTAGE-RATIO SCALE FOR S-8 FILM (AT 18 FPS) AND CASSETTE TAPE

SOUND	TIME	FILM	
Inches	Seconds	Feet	Frames
15/16	1/2	0	9
1-7/8	1	0	18
3-3/4	2	0	36
5-3/8	3	0	54
7-1/2	4	1	0
9-3/8	5	1	18
11-1/4	6	1	36
13-1/8	7	1	54
15	8	2	0
16-7/8	9	2	18
18-3/4	10	2	36
22-1/2	12	3	0
28-7/8	15	3	54
30	16	4	0

For tape running-speed of 3-3/4 in. per sec., multiply sound footage by 2.
For tape running-speed of 7-1/2 in. per sec., multiply sound footage by 4.

APPENDIX I

DEPTH-OF-FIELD CHARTS

S-8 CAMERA FOCUSED AT 6 FEET

	f/1.8	f/2	f/2.8	f/4	f/5.6	f/8	f/11	f/16	f/22
7mm	3 1/2' to 48"	3 1/2' to inf.	3' to inf.	2 1/2' to inf.	2' to inf.	1 1/2' to inf.	1 1/2' to inf.	1' to inf.	9" to inf.
10mm	4 1/2' to 11 1/2'	4' to 13'	3 1/2' to 25'	3' to inf.	2 1/2' to inf.	2 1/2' to inf.	2' to inf.	1 1/2' to inf.	1' to inf.
14mm	5' to 7 1/2'	5' to 8'	4 1/2' to 9'	4' to 12 1/2'	3 1/2' to 23'	3' to inf.	3' to inf.	2 1/2' to inf.	2' to inf.
18mm	5 1/2' to 7'	5 1/2' to 7 1/2'	5' to 8'	4 1/2' to 9 1/2'	4' to 13'	3 1/2' to 29'	3' to inf.	2 1/2' to inf.	2' to inf.
25mm	5 1/2' to 6 1/2'	5 1/2' to 6 1/2'	5 1/2' to 7'	5' to 7 1/2'	4 1/2' to 9'	4 1/2' to 11'	4' to 17'	3 1/2' to 129'	3' to inf.
40mm				5 1/2' to 6 1/2'	5 1/2' to 6 1/2'	5' to 7'	5' to 8'	4 1/2' to 9 1/2'	4' to 12'
56mm					6' to 6 1/2'	5 1/2' to 6 1/2'	5' to 7'	5' to 7 1/2'	4 1/2' to 8 1/2'

These charts are mounted back to back with two others on pages 210 & 211. It is suggested that they be cut out and laminated. They thus become a convenient tool to carry in the camera case.

S-8 CAMERA FOCUSED AT 15 FEET

	f/1.8	f/2	f/2.8	f/4	f/5.6	f/8	f/11	f/16	f/22
7mm	5' to inf.	4 1/2' to inf.	4' to inf.	3' to inf.	2 1/2' to inf.	2' to inf.	1 1/2' to inf.	1' to inf.	10'' to inf.
10mm	7' to inf.	6 1/2' to inf.	5 1/2' to inf.	4 1/2' to inf.	3 1/2' to inf.	2 1/2' to inf.	2' to inf.	1 1/2' to inf.	1 1/2' to inf.
14mm	10' to 38'	9' to 47'	8' to inf.	6 1/2' to inf.	5 1/2' to inf.	4 1/2' to inf.	3 1/2' to inf.	2 1/2' to inf.	2' to inf.
18mm	10 1/2' to 27'	10' to 30'	9' to 51'	7 1/2' to inf.	6 1/2' to inf.	5 1/2' to inf.	4 1/2' to inf.	3 1/2' to inf.	2 1/2' to inf.
25mm	12' to 20'	12' to 21'	10 1/2' to 25'	9 1/2' to 37'	8 1/2' to 92'	7' to inf.	6' to inf.	4 /12' to inf.	4' to inf.
40mm	14' to 16 1/2'	13 1/2' to 17'	13' to 18'	12 1/2' to 19 1/2'	11 1/2' to 22'	10 1/2' to 28'	9 1/2' to 43'	8' to 247'	6 1/2' to inf.
56mm	14 1/2' to 15 1/2'	14 1/2' to 16'	14' to 16 1/2'	13 1/2' to 17'	13' to 18'	12' to 20'	12 1/2 to 23'	10' to 30'	9' to 48'

APPENDIX J

S-8 CAMERA FOCUSED AT 30 FEET

	f/1.8	f/2	f/2.8	f/4	f/5.6	f/8	f/11	f/16	f/22
7mm	6' to inf.	5 1/2' to inf.	4' to inf.	3' to inf.	2 1/2' to inf.	2' to inf.	1 1/2' to inf.	1' to inf.	10'' to inf.
10mm	9' to inf.	8' to inf.	6 1/2' to inf.	5' to inf.	4' to inf.	3' to inf.	2 1/2' to inf.	1 1/2' to inf.	1 1/2' to inf.
14mm	14' to inf.	13' to inf.	10 1/2' to inf.	8 1/2' to inf.	6 1/2' to inf.	5' to inf.	4' to inf.	3' to inf.	2 1/2' to inf.
18mm	16' to 350'	15' to inf.	12 1/2' to inf.	10' to inf.	8' to inf.	6 1/2' to inf.	5' to inf.	3 1/2' to inf.	3' to inf.
25mm	19 1/2' to 65'	19' to 75'	16 1/2' to inf.	14' to inf.	11 1/2' to inf.	9' to inf.	7' to inf.	5 1/2' to inf.	4' to inf.
40mm	25' to 38'	25' to 39'	23' to 45'	21' to 56'	18 1/2' to 87'	15 1/2' to inf.	13 1/2' to inf.	10 1/2' to inf.	8 1/2' to inf.
56mm	27' to 33'	27' to 34'	26' to 36'	24' to 39'	23' to 45'	20' to 58'	17 1/2' to 90'	15' to inf.	12 1/2' to inf.

S-8 CAMERA FOCUSED AT INFINITY

	f/1.8	f/2	f/2.8	f/4	f/5.6	f/8	f/11	f/16	f/22
7mm	7' to inf.	6 1/2' to inf.	4 1/2' to inf.	3 1/2' to inf.	2 1/2' to inf.	2' to inf.	1 1/2' to inf.	1 1/2' to inf.	10'' to inf.
10mm	12' to inf.	11' to inf.	8' to inf.	5 1/2' to inf.	4' to inf.	3' to inf.	2 1/2' to inf.	2' to inf.	1 1/2' to inf.
14mm	24 1/2' to inf.	22' to inf.	16' to inf.	11 1/2' to inf.	8' to inf.	6' to inf.	4 1/2' to inf.	3' to inf.	2 1/2' to inf.
18mm	33' to inf.	30' to inf.	22' to inf.	15' to inf.	11' to inf.	7 1/2' to inf.	5 1/2' to inf.	4' to inf.	3' to inf.
25mm	56' to inf.	50' to inf.	36' to inf.	25' to inf.	18' to inf.	12 1/2' to inf.	9 1/2' to inf.	6 1/2' to inf.	5' to inf.
40mm	144' to inf.	130' to inf.	92' to inf.	65' to inf.	46' to inf.	32' to inf.	24' to inf.	16' to inf.	12' to inf.
56mm	280' to inf.	253' to inf.	180' to inf.	126' to inf.	90' to inf.	63' to inf.	46' to inf.	31' to inf.	23' to inf.

FILM-TAPE SYNCHRONIZER
(For Use with S-8 Film and Cassette Tape.)

APPENDIX K

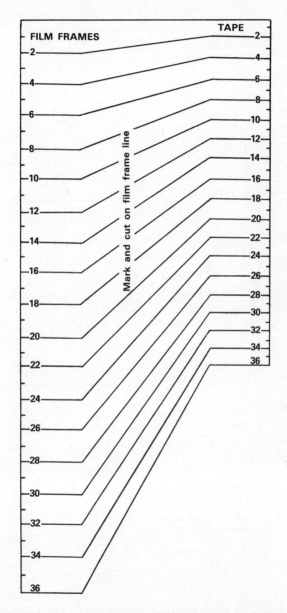

For convenient use, cut out this page and mount it on heavy cardboard. When the glue is dry, cut along the lines of the synchronizer. Not for use with Standard-8. Measure film on left side, tape on right. At any given frame division, tape and film playing time will be equal.

216

218